IMAGES
*of America*

# HELENA

## ALABAMA

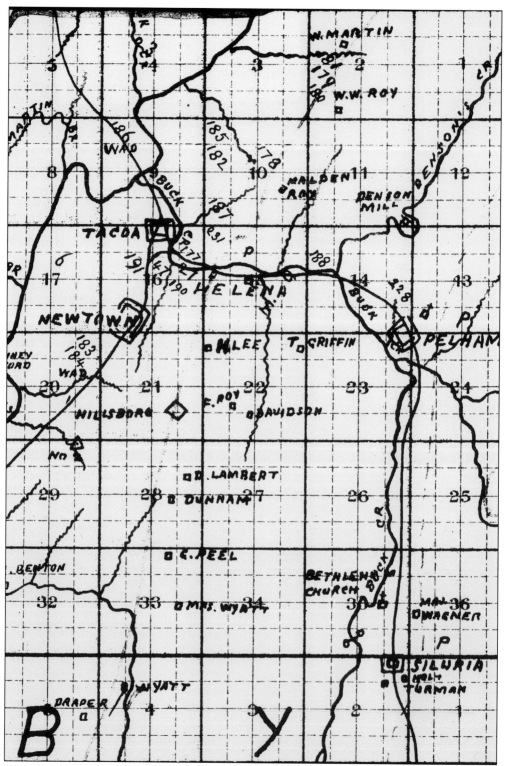

**Joseph Squire's Map of Helena and Environs, 1885.** (Ken Penhale.)

IMAGES
*of America*

# HELENA
## ALABAMA

Ken Penhale and Martin Everse

ARCADIA
PUBLISHING

Published by Arcadia Publishing,
Charleston, South Carolina

Printed in the United States of America

Library of Congress Catalog Card Number: 98088697

For all general information contact Arcadia Publishing at:
Telephone 843-853-2070
Fax 843-853-0044
E-Mail arcadia@charleston.net
For customer service and orders:
Toll-Free 1-888-313-2665

Visit us on the Internet at www.arcadiapublishing.com

To two very patient and understanding wives,
Mary Louise Penhale and Sandra McCool Everse.

*Author's note:* This book was supported in part by the City of Helena and the Alabama Historic Ironworks Commission. Additionally, the authors are indebted to the many people who loaned photographs and documents and shared information. The list of names is too long to thank each one individually, but without their generous assistance, this book would not have been possible. A special note of gratitude, however, is due to Madine and Earl Evans for their years of assistance and research, and Bill Bramblett and Floyd Naish for sharing their lifetime memories of Helena.

# CONTENTS

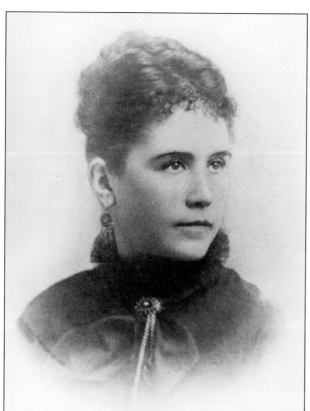

**THE FACE THAT LAUNCHED A NEW TOWN.** Helen Lee won the heart of railroad construction engineer Peter Boyle during the Civil War and had a town named for her—Helena. (Ken Penhale.)

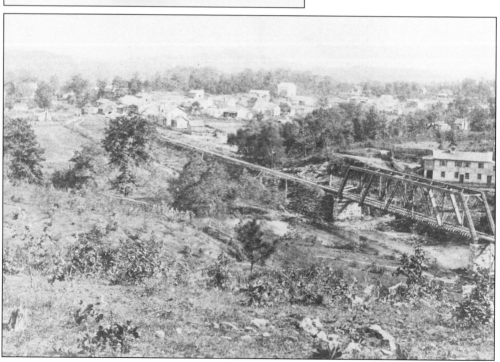

**EARLIEST KNOWN VIEW OF HELENA, C. 1878.** (Ken Penhale.)

# INTRODUCTION

On a spring day in 1814, General Andrew Jackson and his army of Tennessee volunteers decisively defeated the Creek Indians at Horseshoe Bend, ending a war and opening a vast new territory for white settlement. Within a year, land-hungry pioneers began making their way into what would become Shelby County and present-day Helena. Attracted by what a government surveyor called "a valley of very inviting land, with the finest springs and fairest prospect of health," whole communities from the older states packed up and moved into the area. The rush became so great, it was known as "Alabama Fever."

The Griffin and Lee families were two of the first to hack their way into what would become Helena. As the land filled with settlers, roads were cut and where the Ashville-Elyton-Selma and Tuscaloosa Roads crossed, a small community grew. A post office named Cove was established there in 1849. Seven years later, the name was changed to Hillsboro. Today, the intersection of County Roads 52, 17, and 261 roughly corresponds to the location of this original village.

The Civil War transformed Hillsboro, and a romance in the middle of that war changed the name of the town once again. To equip armies, the South was forced to industrialize nearly overnight. The Scotch miner, Billy Gould, and two partners, Charles and Fred Woodson, acquired 1,700 acres of land and dug two mines, a vertical shaft 130 feet deep near the Cahaba and a roughly horizontal slope 400 feet. On good days, these men could produce 75 tons of coal, all of which was transported to a weapons manufacturing plant at Selma. The 12 coke ovens that now serenely guard the confluence of Buck Creek and the Cahaba River may have been constructed at this time. Monk, Edwards, and company also opened mines nearby, as did the Red Mountain Iron and Coal Company. Smaller operations, called "bomb proofs," which were shallow drifts in seams close to the surface, were scattered through the hills and hollows near town. Indeed, by 1864, there were so many people mining coal or wanting to mine coal that the chief engineer for the Red Mountain Company complained that "coal fever" prevailed in the area, and coal land sold for the exorbitant price of $100 per acre.

About 1864, a rolling mill capable of producing bar iron was built by Hannon, Offutt, and Company of Montgomery on Buck Creek, under the direction of Thomas S. Alvis, an experienced ironmaster from Virginia. Called the Central Iron Works, this mill was situated on the South and North Railroad, a track that had been pushed just north of Hillsboro from Limekilns (Calera) during the war, on its way to the Red Mountain Company's blast furnace at what is today called Oxmoor. The line had been graded and bridged all the way to Brock's Gap by the spring of 1865 by Peter Boyle, the construction engineer for the railroad, but in all

probability the working railhead was near the rolling mill on Buck Creek. Here Peter Boyle met the beautiful and enchanting daughter of Needham Lee Jr., and fell in love. When it came time to call this terminal something, Boyle named it Helena Station, forever memorializing his wartime romance with Helen Lee.

James Harrison Wilson, a 27-year-old Union general who loved to discuss poetry, and 10,000 Federal troopers would, in a few hours, put an end to four years of industrialization. On March 30, 1865, they poured across the South and North Alabama Railroad bridge and torched everything of significance in their path. It would be years before the destruction wrought by the brief raid through Helena would be overcome, and physical scars would heal much sooner than emotional ones.

A few years after the war, development began anew. The railroad was rebuilt in the early 1870s, and in 1873, the rolling mill was reopened by Rufus Cobb, a future governor, B.B. Lewis, a future University of Alabama president, and Richard Fell, an experienced ironmaster. Railroad spurs branched out from Helena in all directions to serve new coal mines. The Eureka Company constructed a large battery of coke ovens in the 1870s to turn coal from Helena mines into coke for the reconstructed blast furnaces at Oxmoor. With all activity centering on the railroad, rolling mill, and Buck Creek, and stores springing up there to profit from this busy area, Hillsboro slowly ceased to exist and the new town of Helena was incorporated in 1877.

In 1880, Helena was described by a news correspondent as a "mining and manufacturing town." It was a rough place that contained six mercantile stores, one drugstore, two hotels, and a number of boardinghouses. The federal census also enumerated a number of women listed as prostitutes. By the following decade, the town was truly prospering. The rolling mill had been expanded and modernized and the number of merchants had increased. There were barber shops, shoe shops, doctors, a dentist, dry goods and drugstores, a blacksmith, meat market, and furniture store. The Louisville and Nashville Railroad had also built a large yard at Helena to facilitate the shipping of coal and coke.

At the beginning of the 20th century, prospects for the town were mixed. The rolling mill fell on hard times and was eventually dismantled in 1923. The coal mines in the area suffered from shrinking markets and labor unrest with the exception of a few years during WW I. The mine at Mossboro, just outside Helena, was closed after a horrible explosion killed a number of miners. During this same time, electricity and telephone service began and a swimming pool, skating rink, and movie theatre were built. The town was reincorporated in 1917 and elected Charles Hinds its mayor.

Yet the economic uncertainties were nothing compared to what happened on Friday morning, May 5, 1933. Out of the morning darkness a little after 3 a.m., a tornado ripped through the heart of Helena. First reports listed 12 dead and 75 injured. The Baptist, Presbyterian, and Methodist churches were all destroyed, and many of the town's old and fine homes demolished. The town slowly struggled back, again.

For the following 40 years, not much changed. Most of the coal mines were closed, though Acton, just north of Helena, operated until after World War II. County roads were paved in the 1950s, but for the most part, Helena was off the beaten path, a sleepy little town that had seen better days. Then, beginning in the early 1970s, things began to change. The metropolitan sprawl from Birmingham spread south into Shelby County and Helena became a very desirable place to live and raise a family. Today, Helena is one of the fastest growing municipalities in the state and has far outgrown even the wildest dreams of its most ardent promoters in the heady days of the 1880s and 1890s.

# *One*

# EARLY FAMILIES

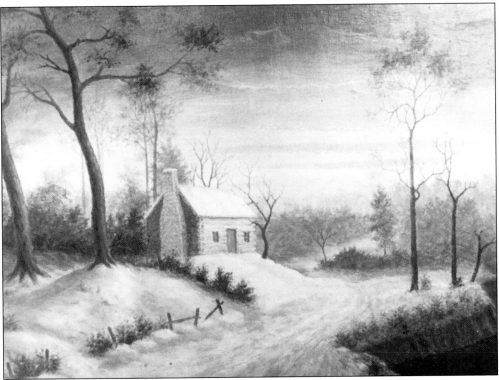

JONES GRIFFIN CABIN, C. 1816. Some of the earliest settlers were former soldiers who had first gazed upon this "valley of very inviting land," chasing Creek Indians with Andrew Jackson. Jones Griffin was such a man. According to family tradition, he was the first over the breastworks at Horseshoe Bend, and at war's end, was a colonel. Returning to Tennessee, he married Mary "Polly" Lee, a sister of Needham Lee Sr. By 1816, the couple was comfortably situated in a cabin built at the confluence of Beaverdam Creek and the Cahaba River. An itinerant French artist painted this unusual winter scene two years later. The ruins of the cabin were visible until the 1930s. (Dolly Carroll.)

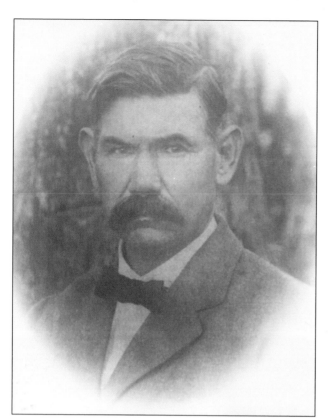

**THOMAS HOGAN GRIFFIN.** The Griffin family prospered and multiplied, spreading over north Shelby County. Jones Griffin's grandson, Thomas Hogan Griffin (1851–1912), was a successful farmer, a Mason, justice of the peace, Methodist church member, and also conducted the 1880 census of the district around Helena. He married twice. His first wife was Maggie McMillan, and after her death, he wed Leona Lee. (Helena Masonic Lodge.)

**EDWARD LEE AND MARTHA ROY LEE.** The Lees thrived in Shelby County. The family's progenitor, Needham Lee Sr., father of 18 children including Edward Lee (1812–1891), arrived in the area from East Tennessee in 1816. During the Civil War, Edward served with the 20th Alabama Infantry. He was a Presbyterian and owned a large farm near Helena along the Cahaba River. He married Martha Roy (1820–1899), the sister of Malden Roy. (Jo Lonas.)

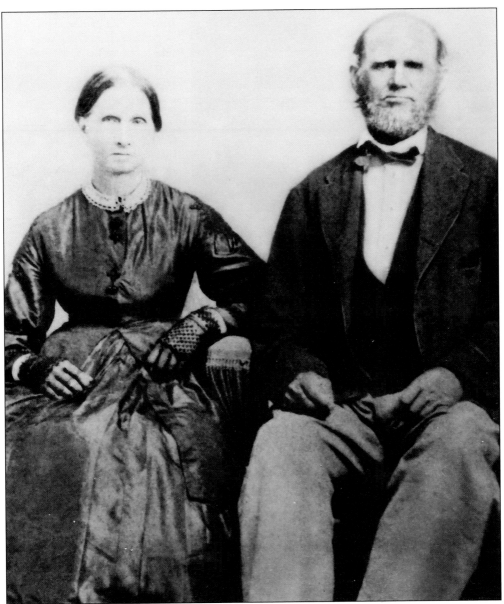

**NEEDHAM LEE JR. AND MARTHA STRIPLING BROADNAX LEE.** Probably the most famous of Needham Senior's 18 children, at least around Helena, was Needham Junior (1808–1896). The younger Needham was eight years old when he made the trek from Hawkins County, Tennessee, and he had probably heard wondrous tales of the Cahaba River valley from two older brothers who had served in the Creek Indian War. In the spring of 1829, Needham eloped with Nancy Whorton, and they eventually had ten children. All four sons served in the Confederate Army. After Nancy died in 1869, Needham married the widow Martha Stripling Broadnax (1834–1904). Needham was a farmer, a Presbyterian, Mason, was elected tax collector in 1847, and served for 50 years as the justice of the peace for Beat 6. (Ken Penhale.)

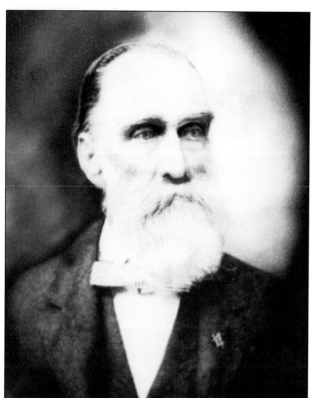

**EDWARD FIELDS LEE.** The oldest son of Needham Lee Jr. was Edward Fields Lee (1831–1912). Early Helena families are renowned for tangled kinships, and the large Lee family had many. Edward's wife, Sue Stripling, was the niece of his father's second wife. Together, they had eight children, the eldest child (and only son) dying in infancy. Edward taught school briefly in Helena and moved to Birmingham to try his hand at real estate. (Tyler Posner.)

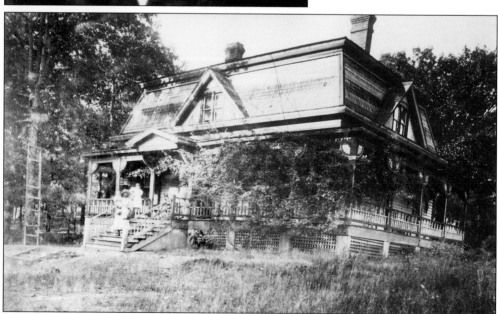

**TUCKER-LEE HOUSE, C. 1913.** J.L. Tucker constructed this fine Victorian residence around 1890. Following the Panic of 1893 and the collapse of his real estate business, Edward Lee retired to this Helena house, where he passed his final days reminiscing about his years with the 2nd Alabama Cavalry during the Civil War and sipping mineral water from the spring behind the house. (Randy Robinson.)

12

**JAMES LACEY LEE.** The youngest son of Needham Lee Jr. was James Lacey Lee (1841–1930). During the Civil War, he served in the 2nd Alabama Cavalry with his older brother Edward. He was a farmer, working the land where Joe Tucker Park and the municipal complex are now located. (Ken Penhale.)

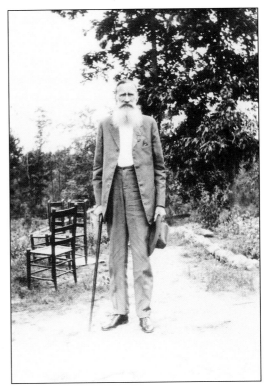

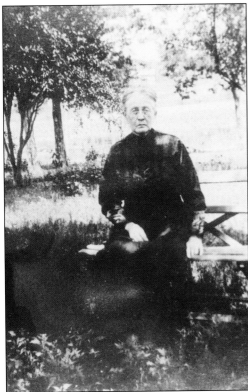

**LOUISA ST. JOHN LEE.** The September after James Lacey Lee returned from the war, he married Louisa St. John (1847–1926). They had six children.

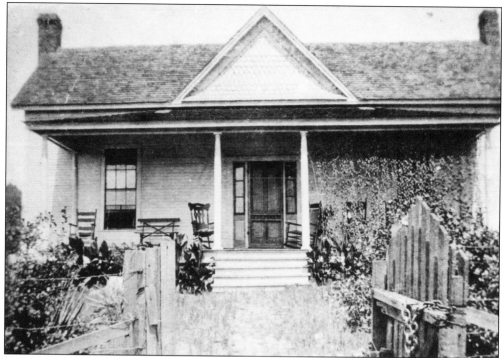

**JAMES LACEY LEE HOUSE, C. 1920.** Sometime after James and Louisa were married, they built this home on Rolling Mill Street in Helena. They both died before the terrible 1933 tornado struck the town, and Walter Simmons and his wife were living there when the tornado struck. The house was demolished, and Mrs. Simmons was killed in the holocaust.

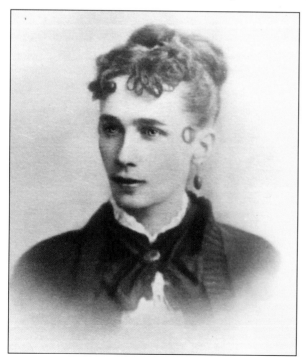

**MARTHA MALISA LEE.** The fifth of Needham Lee's six daughters, Martha Malisa (1850–1935), married Helena merchant Lewis Pickney Leonard in 1870. When her husband died in 1892, she moved to Birmingham. The couple's only child, Helen Lee Leonard, was the second wife of the famous Alabama industrialist and U.S. Congressman, Truman H. Aldrich. (Frances Haynesworth.)

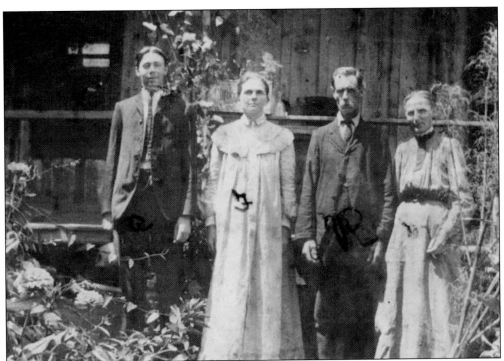

**MITCHELL AMOS GILLAM, UNKNOWN, RUBIN GILLAM, AND WIFE MARY LEE GILLAM.**
Mary Lee (1851–c. 1925) married Rubin Gillam (1850–1935), who at one time operated a meat market in Helena. Mammie, as she was called, was the mother of Mitchell Amos Gillam and the daughter of Henry R. Lee, a brother of Needham Lee Jr. and Nancy Drake Lee. Henry was a carpenter and gifted musician and an ancestor of many of today's Helena residents. (Ken Penhale.)

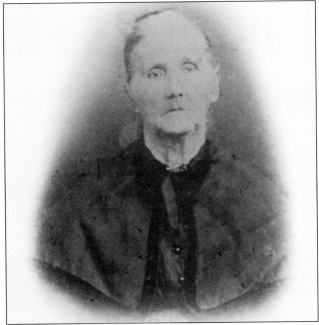

**MARGARET ROY.** Isaac Roy and his wife, Margaret (1793–1896), migrated to Alabama around 1820 from South Carolina. Within a decade the Roy and Lee families were intertwined. The oldest son, Malden, married Mary Lee. A daughter, Martha, wed Edward Lee. Mary and Edward were children of Needham Lee Sr. (Eugene Roy.)

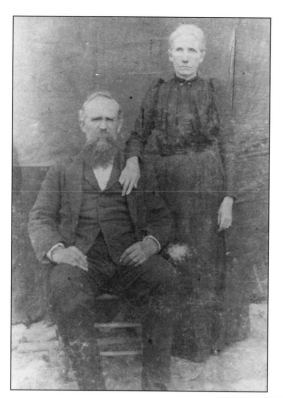

**WILLIAM WHARTON ROY AND ELIZA READER ROY.** William (1836–1916) was the son of Malden and a veteran of the 30th Alabama Infantry. When his wife, Eliza (1842–1908), died, she was buried in the Helena cemetery. Within weeks he remarried. During the family stir that followed, he secreted Eliza's remains from Helena, reburying her in the family plot north of town. (Mary Lee Stewart.)

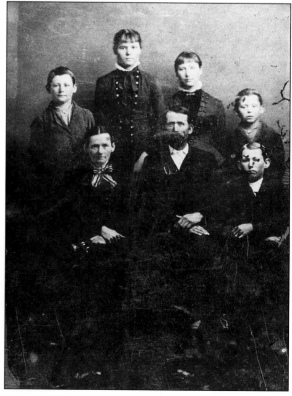

**LAFAYETTE NEEDHAM ROY FAMILY, c. 1885.** From left to right are: (front row) Caroline, Lafayette, and Charles; (back row) Robert, Sally, Mary, and Eugene. Another son of Malden Roy, Lafayette (1838–1923), hobbled on a peg leg, the result of a leg ailment incurred during his three years of service in the 30th Alabama Infantry. Shortly after the Civil War, he married Caroline Melindy Davidson (1842–1925), a sister of John W. and James E.R. Davidson. (Jack Johnsey.)

**ROBERT LITTLE.** A restless man, Robert Little (1807–1882) moved from North Carolina to Georgia to Coosa County, Alabama, before settling after 1850 in what is today western Helena, along County Road 13. According to family tradition, he was of German descent and spoke in broken English. (Charles Griffin.)

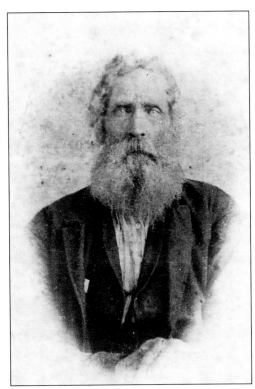

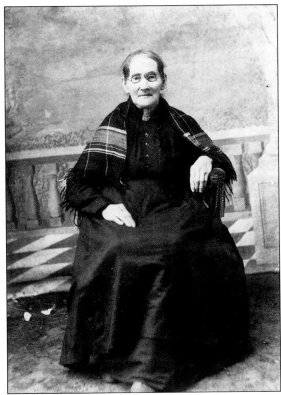

**VERLINDA ANN ARNOLD LITTLE.** The wife of Robert Little, Verlinda Ann Arnold (1808–1910) survived all but two of her eight children. She lived on her farm well into her 90s, often walking a mile and a half to visit a nearby daughter. "Grandma" Little died at the age of 102 at the home of her son-in-law, John W. Cost, in Elliottsville. Her funeral was held at Harmony Church in Helena. (Charles Griffin.)

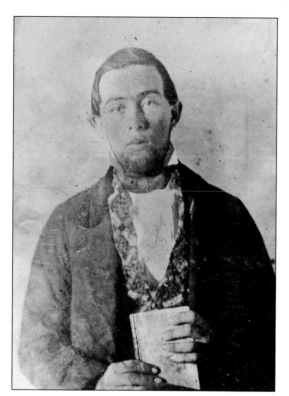

**AARON FLEMING.** The Little and Fleming family farms were nearby one another, and so it was not surprising that Aaron (1835–1865), a year before the Civil War began, wooed and won the hand of Nancy Jane Little. Aaron joined the Confederate Army early in 1862 and was sent to Virginia. He survived the fighting there but disappeared on his way home in 1865. (Charles Griffin.)

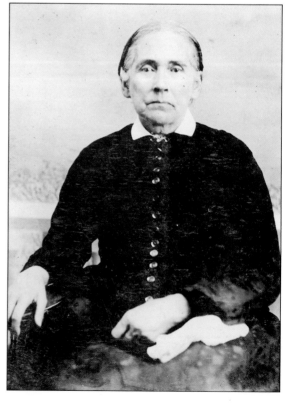

**NANCY JANE LITTLE FLEMING.** The daughter of Robert and Verlinda Ann Little, Nancy Jane (1835–1893) bore two daughters, Ella Virginia (1861), and Missouri Thomas Fleming (1862), who was named for her father who had left for the war before her birth. Both daughters married well. (Charles Griffin.)

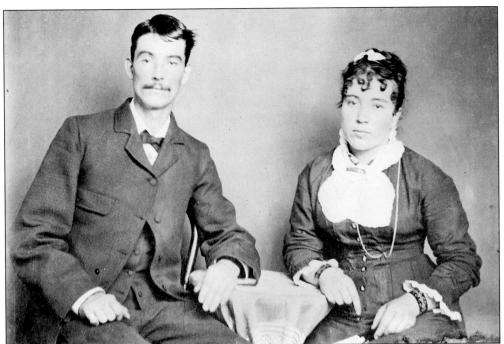

**DAN DRAPER AND ELLA VIRGINIA DRAPER, C. 1882.** Dan Draper (1856–1900) worked at the rolling mill in Helena. His wife, Ella (1861–1924), operated a boardinghouse on the corner of Main Street and First Avenue for workers at the rolling mill. The Drapers had four children, all born in Helena. (Charles Griffin.)

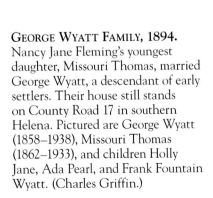

**GEORGE WYATT FAMILY, 1894.** Nancy Jane Fleming's youngest daughter, Missouri Thomas, married George Wyatt, a descendant of early settlers. Their house still stands on County Road 17 in southern Helena. Pictured are George Wyatt (1858–1938), Missouri Thomas (1862–1933), and children Holly Jane, Ada Pearl, and Frank Fountain Wyatt. (Charles Griffin.)

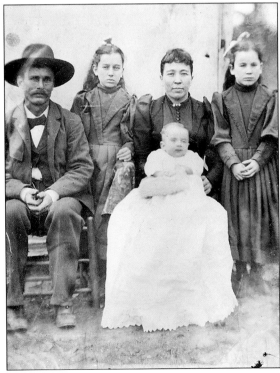

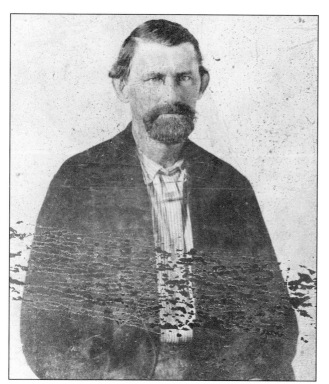

JOHN WALTER DAVIDSON. The Davidson family arrived in Helena from South Carolina in the 1850s. A son of Charles and Lucinda Alexander Davidson, John Walter (1824–1882) operated a gristmill on Buck Creek and in 1873 hired Joseph Squire to survey Helena into lots with streets and avenues. He donated the land where the present elementary school is located, as well as property for the Presbyterian church. (Ken Penhale.)

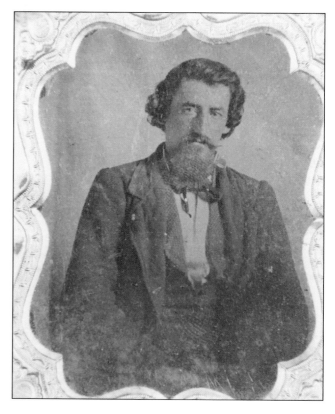

JAMES EDWARD RUFUS DAVIDSON. According to tradition, James (1832–1901) was a blacksmith and an expert carpenter who built many of the finer Helena houses that were destroyed by the 1933 tornado. He was a brother of John Walter and father of six children, who were all born in Helena. (Ruth Davidson.)

# *Two*

# INDUSTRY

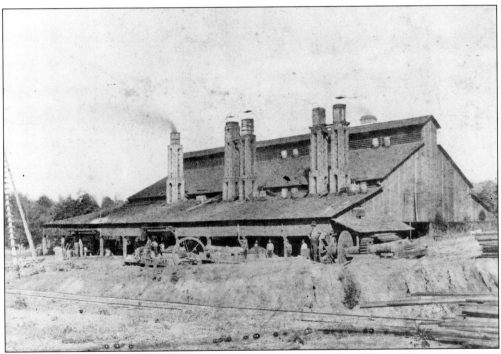

**CENTRAL IRON WORKS, C. 1875.** During the final years of the Civil War, Montgomery merchants Hannon, Offutt, & Company built a rolling mill in Helena next to Buck Creek. Called the Central Iron Works, the plant's construction was superintended by Thomas S. Alvis, a Virginia ironmaster who had recently completed a rolling mill for the Confederate government at Selma. The Central Iron Works had just begun operation when it was destroyed by Union cavalry on March 30, 1865. After lying abandoned for seven years, Rufus W. Cobb, B.B. Lewis, and Richard Fell bought the property at a tax sale, organized the Central Iron Works Company, repaired the building and machinery, and began operations in 1873. (Ken Penhale.)

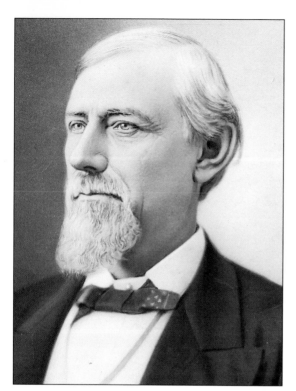

**RUFUS WILLS COBB.** R.W. Cobb (1829–1913) was a lawyer, soldier in the 10th Alabama Infantry, a state senator (1872–1876), and a two-term governor (1878–1882). In 1888, he accepted an appointment as Shelby County Probate Judge. He moved to Helena in 1873 and assumed the position of president of the Central Iron Works. (Charles A. Fell Jr.)

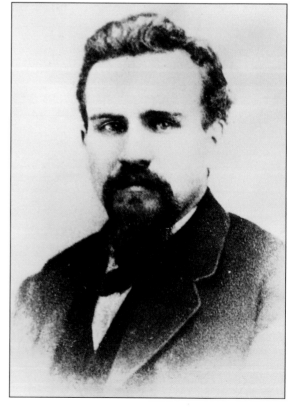

**RICHARD FELL JR.** Following his father to Helena in 1873, Richard Fell Jr. (1844–1914) served as secretary-treasurer of the Central Iron Works Company. Later, he operated coal mines at Zenida, just outside Helena. He and his family left Helena in 1893 and moved to Birmingham. (Charles A. Fell Jr.)

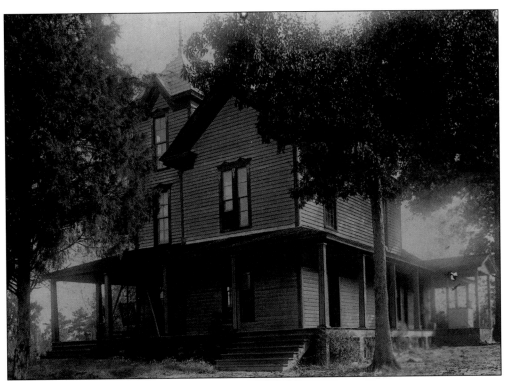

**R.W. COBB HOUSE.** R.W. Cobb moved to Helena in 1873 and in 1884 had this house built on Rolling Mill Street for his wife, Frances, the daughter of Richard Fell, and himself. The house was destroyed in the 1933 tornado. While Cobb was governor and visiting home, the rolling mill superintendent appealed to him for help after a boilerman had to be carried away sick and no one could be found to replace him. "I reckon I can learn," Cobb said, and leaving this imposing structure wearing his hunting suit he stood unflinchingly in front of eight large boilers alone and shoveled coal for three days. (Randy Robinson.)

**DORA COBB FELL.** The Central Iron Works provided more than employment for men of the area; it sparked a romance as well. R.W. Cobb's daughter, Dora, married Richard Fell Jr. on June 28, 1882, at 10 a.m. in the Cobb home. The bridal couple left immediately on a three-week honeymoon. (Alabama Department of Archives and History.)

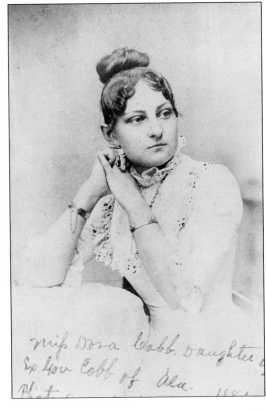

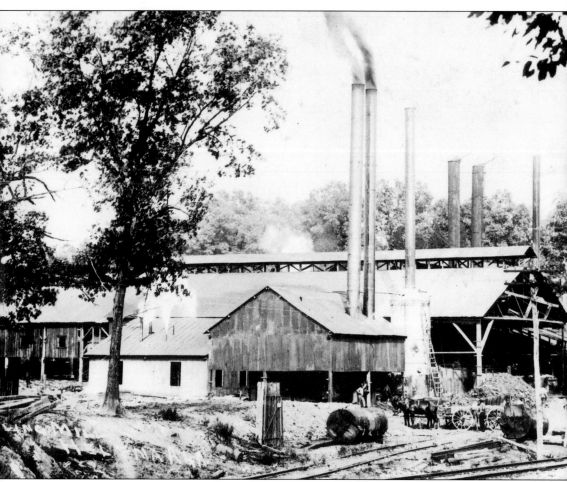

CENTRAL IRON WORKS, C. 1888. "Passing the mouths of several coal pits on the banks of the Cahaba River," wrote a news correspondent in 1875, "we reached Helena, the center of a flourishing coal and iron business. Here are the Central Works, where iron is rolled. The works are devoted almost exclusively to making iron ties or bands for baling cotton. They have almost a monopoly of this important industry, and have a ready market for all they can manufacture." In 1883, the works switched to making nails in an effort to keep profitable in declining economic times. In 1888, however, the Central Iron Works Company went bankrupt. (Ken Penhale.)

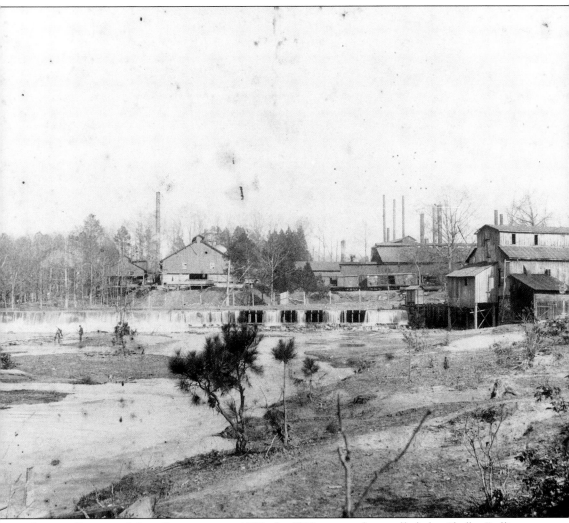

**SHELBY ROLLING MILL COMPANY, C. 1890.** In 1889, a new firm called the Shelby Rolling Mill Company was organized to operate the works at Helena. By November of that year, the new company, according to a Birmingham paper, "had gone to work in earnest, enlarging the old rolling mill and covering the entire structure with iron roofing. Six or eight new furnaces are to be built and three batteries of new boilers put up. A large force of hands are engaged in the work, and the mill will be in shape to commence operations in a short time." George H. Dudley of Florence was president, E.A. Hopkins of Philadelphia vice president, and Richard Fell Jr. secretary and treasurer. The new company boasted an annual capacity of 8,000 tons of merchant bar, band iron, and light T-rails. Within three years, this company would also fail. (Ken Penhale.)

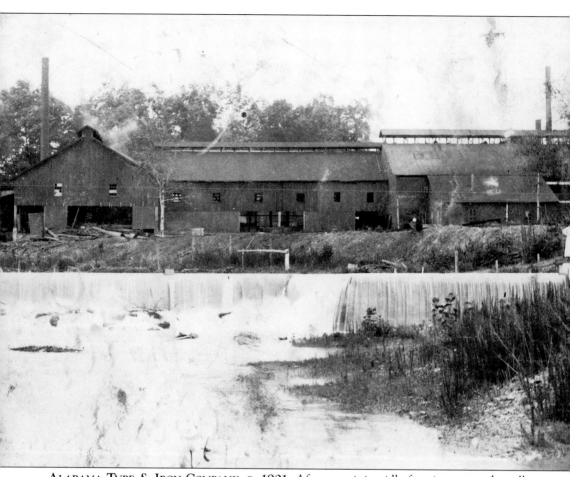

**ALABAMA TUBE & IRON COMPANY, C. 1901.** After remaining idle for nine years, the rolling mill was purchased by the Alabama Tube and Iron Company in 1901. F.L. Clark was president, William S. Roberts vice president and general manager, and V.A. Moore secretary and treasurer. Wrought iron pipe from 1/4 to 3 inches in diameter was manufactured here, with an annual capacity of 20,000 tons. A galvanizing plant and machine shop were also connected with the works. By 1904, this company, too, failed. (Ken Penhale.)

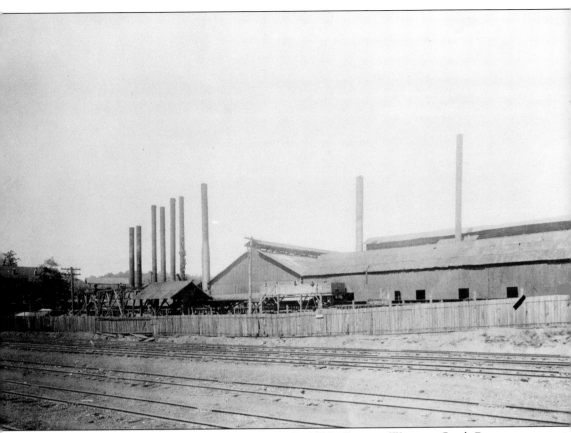

**CONNERS-WEYMAN STEEL COMPANY, C. 1913.** In 1908, Conners-Weyman Steel Company was incorporated with offices in the Brown-Marx building in downtown Birmingham. The old Helena works were overhauled and remodeled to produce hoops, light bands, and once again, cotton ties. Annual capacity was set at 15,000 tons. In 1920, George W. Conners bought out S. T. Weyman's interest in the company. In 1923, the works at Helena were dismantled and demolished and the usable portions sent to the Conners Steel Company works at Woodlawn, ending nearly 60 years of the iron industry in Helena. (Randy Robinson.)

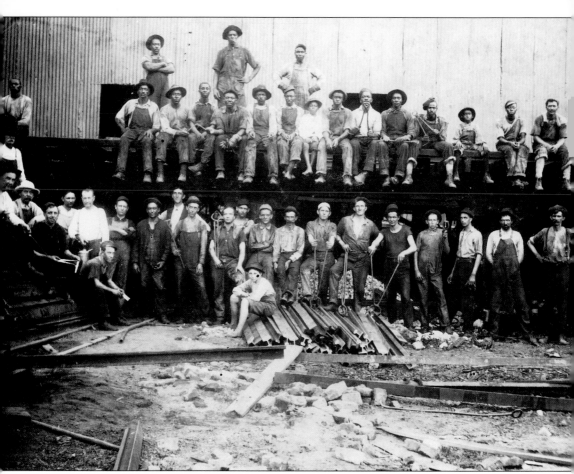

**ROLLING MILL WORKERS.** An Helena correspondent to the county paper crowed in 1909 that "indications are that the rolling mill at this place will resume operation in a few days. A crowd of men were put to work for the purpose of moving the machine shop to a more suitable place. It will take about ten days to complete the shop, and as soon as it is completed the mill will open up in full blast. It will give employment to about 300 men." (Ken Penhale.)

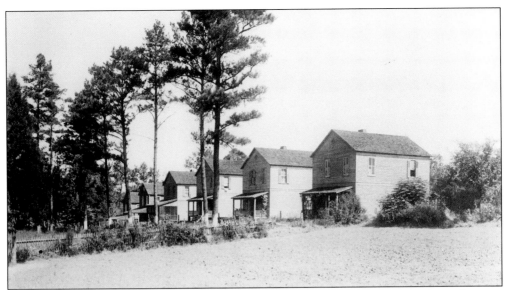

**ROLLING MILL QUARTERS.** In the Alabama coal and iron industries, company housing was often dismal, but this seemed not to be the case with the rolling mill at Helena. (Randy Robinson.)

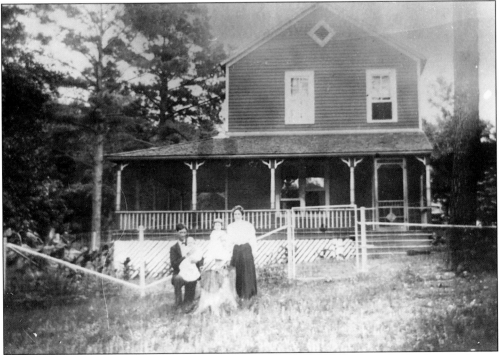

**SUPERINTENDENT'S HOUSE.** The common rolling mill worker family probably shared a house with others. The superintendent, however, was sole occupant of a slightly nicer house, befitting his higher station with the company. Pictured are Joseph B. Johnston and his wife and two children. Johnston left the mill's employment to direct the Presbyterian Orphan's Home in North Carolina. (Bill Johnston.)

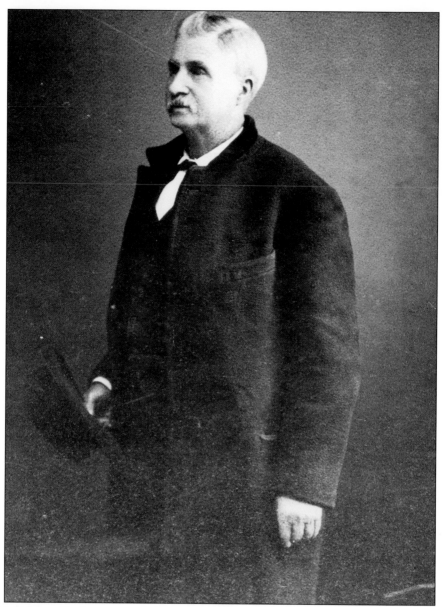

**JOSEPH SQUIRE.** Squire was a mining engineer from Rochdale, England, who arrived in the United States in 1850. He served a year's apprenticeship to learn the machinist trade at the Peabody Furnace in Rhode Island, then traveled west to Kansas and Nebraska, where he opened coal mines. While visiting St. Louis, he heard glowing reports of vast coal fields in Alabama, and by the fall of 1859 he was working for the Alabama Coal Mining Company near Montevallo. For the next half century, Squire would play a significant, yet largely overlooked today, role in the development of the coal industry in Alabama. He moved to Helena in 1871 and lived there the remainder of his life. Among his accomplishments noted in his obituary, he was credited with "staking out the Montevallo coal field and the Pratt Mine coal field, and other coal fields, the owners growing immensely rich, while Mr. Squire eked out a mere living." The writer ended by lamenting, "the death of Mr. Squire has removed from us a most worthy and useful citizen. Peace to his ashes." (Ken Penhale.)

**JEMIMA GREENWOOD SQUIRE AND DAUGHTER CLARA.** In 1880, Joseph Squire visited his home in England, where he wooed and won the hand of 18-year-old Jemima Greenwood, the daughter of a musician. A two-year engagement culminated in a New York City wedding at Trinity Church on Broadway on November 14, 1882. Jemima died in Helena in 1890. (Emmie Davidson.)

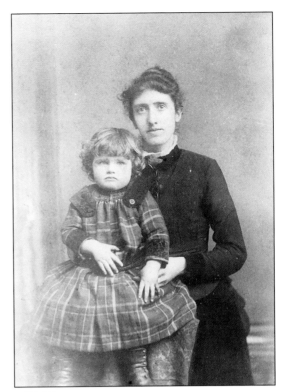

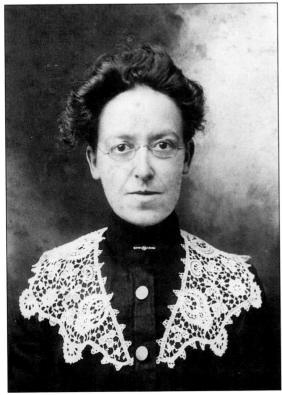

**FLORENCE WOOD SQUIRE.** Joseph and Florrie, as she was called, were married in 1893 in England, following a trans-Atlantic courtship through the mails. Once married, the couple returned with Sarah Wood, the bride's mother, to Helena. (Emmie Davidson.)

**SARAH WOOD, FLORENCE AND JOSEPH SQUIRE.** Though Joseph expressed doubts his new mother-in-law would move to Alabama, she did and lived her remaining years in Helena, where she is buried. This photograph was probably taken shortly after their arrival from England in 1893. (Emmie Davidson.)

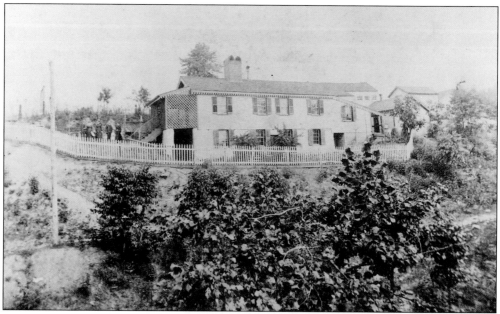

**SQUIRE HOUSE, C. 1895.** Many notable Alabama industrialists visited Squire in Helena to tap his unparalleled knowledge of the Alabama coal fields. Truman H. Aldrich, Henry DeBardeleben, and J.W. Sloss were frequent visitors. (Emmie Davidson.)

32

**CLARA SQUIRE.** Following her mother's death in 1890, Clara spent much of her youth in England, where this photograph was taken about 1899. She was Squire's only surviving child. (Ken Penhale.)

**CLARA SQUIRE POWELL.** This 1940s photograph was taken in front of the Squire House on Buck Creek. Clara and her husband, Thomas Powell, operated a restaurant and hotel in Helena. (Ken Penhale.)

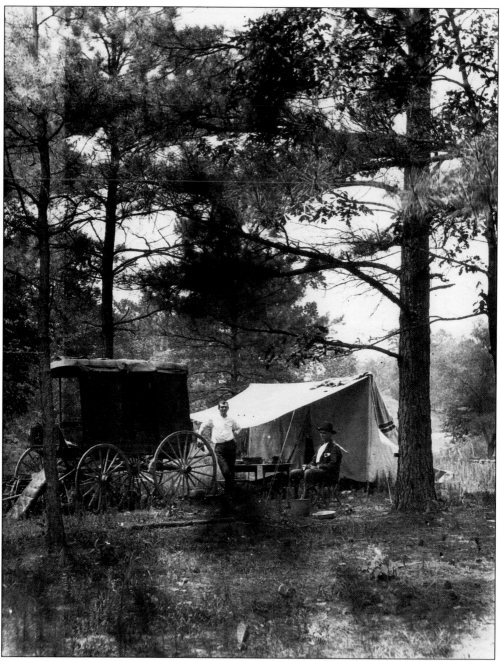

**STATE GEOLOGIST IN CAMP NEAR HELENA.** One of Dr. Eugene Smith's prized possessions was this South Bend, Indiana Studebaker wagon in which he criss-crossed the state. In the 1880s, Smith employed Joseph Squire to write a report on the Cahaba coal field, a study that is still referred to today. Smith and Squire were colleagues and friends for over 30 years. (University of Montevallo.)

**TRUMAN H. ALDRICH.** An early historian wrote that "the name of Truman H. Aldrich heads the list of the first big coal operators of Alabama." A native New Yorker, Aldrich embarked in the coal business in 1873 and soon initiated a life-long business relationship with Joseph Squire. (Frances Haynsworth.)

**HELEN LEE LEONARD ALDRICH.** As close as his association was with Squire, Aldrich had an even closer connection with Helena. He married Helen Lee Leonard, a granddaughter of Needham Lee Jr. (Frances Haynsworth.)

**WILLIAM A. GOULD.** The Scotch miner William A. "Billy" Gould (1830–1912), was a prominent figure in the development of the Alabama coal industry. During the Civil War, Gould, with his partners Charles and Fred Woodson, shipped up to 75 tons of coal a day from a mine near Helena to the Selma arsenal. (Hugh Gould.)

**COKE OVENS.** Near the Gould and Woodson mine stand the ruins of a battery of 12 coke ovens. The origin of the ovens is uncertain, yet it is known that Gould was one of the first to make coke from Alabama coal in Tuscaloosa in the mid-1850s. If these ovens date from Gould's time, they would be the oldest standing coke ovens in the state. (John Reese.)

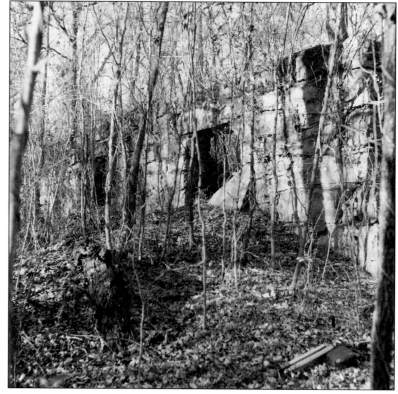

**EARLY COAL MINE, c. 1878.** The Civil War fostered a frenzy of coal mining around Helena. People complained that "coal fever" reigned, driving the price of land over $100 per acre, an exorbitant price for the time. After the war, mining slowly revived. This photograph is one of the earliest known images of a mine around Helena. (Ken Penhale.)

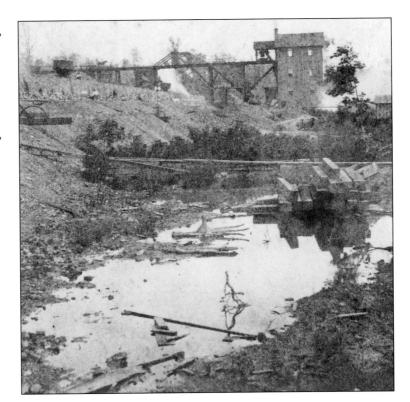

F. R. LEAVITT.        L. WELLS.        B. S. BIBB, JR.

# Red Mountain Coal Co.

F. R. LEAVITT,
*Gen. Manager,*
Helena, Ala.

—OF—

## ALABAMA.

B. S. BIBB,
*Sec'y & Treas'r,*
Montgomery, Ala.

# F. R. LEAVITT & CO., LESSEES.

*After further notice we will offer to the public a First Class quality of Coal at Prices Lower and Delivery More Prompt than any heretofore offered in this market.*

You are therefore respectfully solicited to reserve your orders before purchasing elsewhere. Contracts will be delivered in large and small quantities on the shortest notice. Prices will be furnished in our next card.

## Office at COAL YARD, on Court St.,
**Opposite JANNEY'S FOUNDRY.**

MONTGOMERY, ALA., April 15, 1873.

**RED MOUNTAIN COAL COMPANY.** By the 1870s, the area around Helena was once again pocked with mines and eager miners digging for "black gold," but poor transportation and a weak market stymied efforts to rejuvenate the industry. In 1872, F.R. Leavitt and Company leased the Red Mountain mines, installed a new steam engine and pump, and worked one season before going out of business in 1874. (Ken Penhale.)

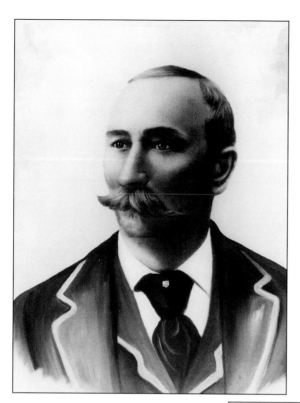

**WILLIAM HENRY PENHALE.** Born in County Cornwall, England, William Henry Penhale was a mine superintendent who first went to work in the United States at Rockwood, Tennessee. He moved to Helena in 1875. For the next 45 years, he worked at mines in the Birmingham area. He died on a Sunday afternoon in 1920 at Townley in Walker County, while inspecting a coal mine he was superintending. (Ken Penhale.)

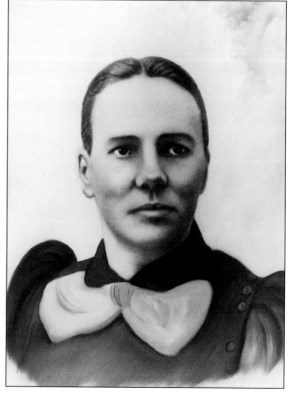

**MARY GRACE PENHALE.** The wife of William Henry Penhale, Mary Grace (1850–1897) raised six children while dutifully following her husband from mining camp to mining camp. Over the years, the family lived at Helena, Oxmoor, Lewisburg, and Henderson in Bibb County near Scottsville. She died at Lewisburg (Fultondale), while her husband was superintendent of the Sloss mines there. (Ken Penhale.)

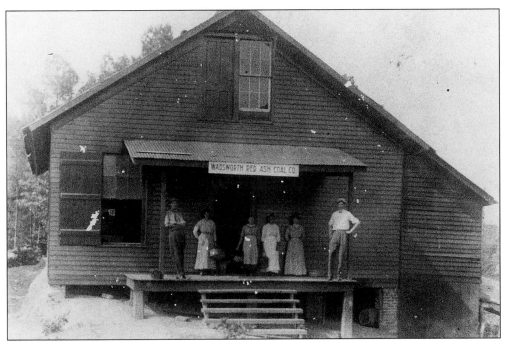

**WADSWORTH RED ASH COAL COMPANY STORE, C. 1918.** Two wealthy New Orleans cotton brokers, J.W. Jay and Leon Gilbert, owned the Wadsworth Red Ash Coal Company. They purchased 1,500 acres of land and planned to spend a million dollars improving their mines at Falliston. The first mine went into operation in 1911 with a 500-ton-per-day capacity of coal so clean that no washer was necessary. (Ruth Naish.)

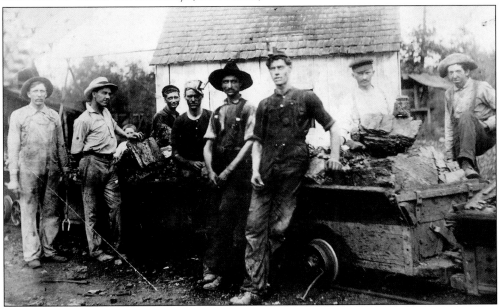

**MINERS, 1908.** Turn-of-the-century coal miners worked long hours for low pay. These men are preparing to begin a shift at a mine near Helena. C.I. Hinds (third from the right) was later a fireboss at the Mossboro Mine and a foreman at Eureka Mine #4. He became Helena's first mayor after the city's reincorporation in 1917. (Ken Penhale.)

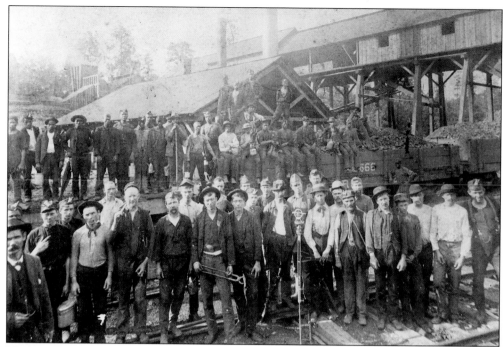

**MINERS, EUREKA COAL MINE #2, MARCH 12, 1910.** The life of a miner was fraught with dangers. Accidents were frequent, and death was a constant companion. A few years before this photograph was taken, some slate and rock in one of the entries of Eureka #2 had fallen on two miners, killing one and badly injuring the other. (Ken Penhale.)

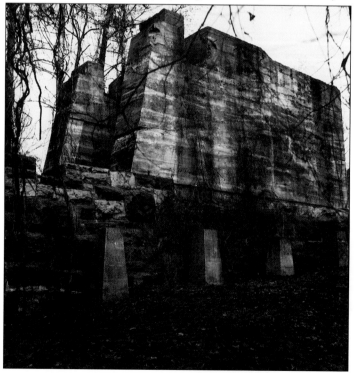

**ENGINE MOUNT, EUREKA COAL MINE #4.** The origins of the Eureka Company went back to the Civil War, and it eventually became one of the largest producers of coal in the area. Very little remains today to even hint at the magnitude of this industry around Helena, except a scattered ruin or barred mine opening lying abandoned in the woods. A giant steam engine once sat upon this mount providing the power to lower men into the mine and pull the dug coal out. (John Reese.)

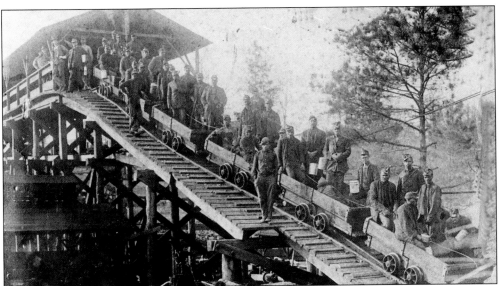

MINERS, EUREKA COAL MINE #2, C. 1915. Coal mining provided employment for many of Helena's residents. The industry also drew a diverse population to the area. Men from Wales, Pennsylvania, and Tennessee, as well as all sections of Alabama worked at #2 Helena around 1915. These men could live half their lives underground, pulling shifts of 12 hours a day. Many of the miners in this photograph are carrying lunch buckets which were necessarily large and contained two meals. (Ken Penhale.)

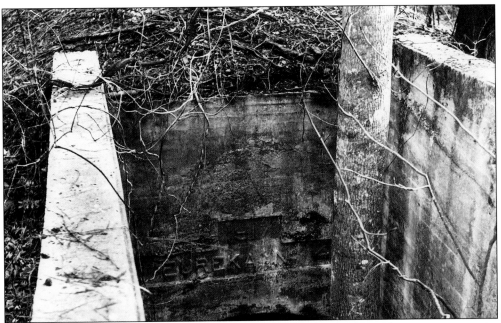

EUREKA COAL MINE #4. World War I caused a surge in the market for coal, so many companies opened new mines. The Eureka Company opened their fourth and final mine in 1917. Following the war, however, the economy slowed. In 1919, 400,000 coal miners across the country, including the Eureka men, struck for a wage increase. Eventually, labor unrest closed the mines forever. (John Reese.)

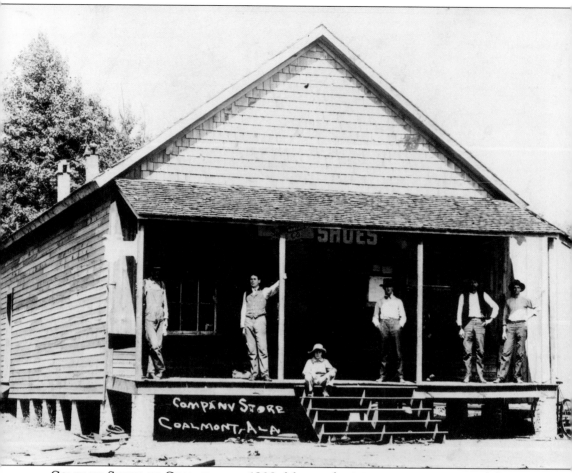

**COMPANY STORE AT COALMONT, C. 1908.** Most coal mining companies operated their own general mercantile stores. Due to the isolated location of many mines, miners were often dependent on the wares found there. The company's prices for those wares were often a source of discontent, and miners often called them "pluck-me" stores. (Ken Penhale.)

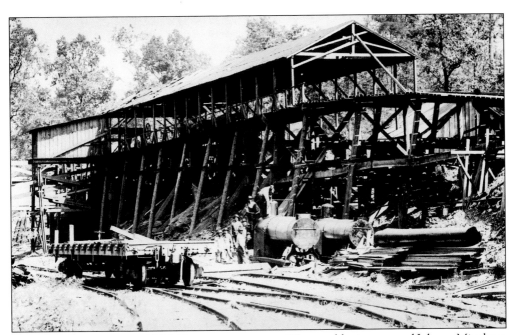

**TIPPLE AT COALMONT, C. 1908.** Twenty years ago, an 86-year-old miner named Johnny Minshew, who came to Coalmont in 1914, remembered the mining town had two mine openings, about 100 houses, a doctor, a barber, a store, and a school where people danced on Saturday night and worshipped on Sunday morning. (Ken Penhale.)

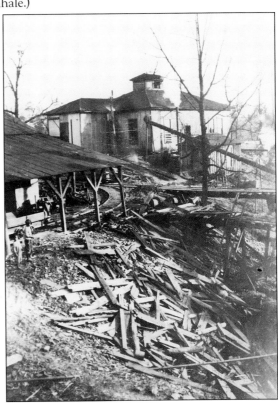

**BOILER HOUSE AT COALMONT, 1908.** A coal mine was a dangerous place to work, both above and under the ground. In the fall of 1908, Fred Orr and January Goodiron, whose job was to keep the fire going in the boilers, were killed instantly when the boilers burst with what news reports called a "tremendous detonation." Goodiron was decapitated, and one of the company owners, R.C. Middleton, was injured, but not fatally so, by a flying brick which hit him in the back. Debris in the foreground of the photograph remains from the explosion. (Ken Penhale.)

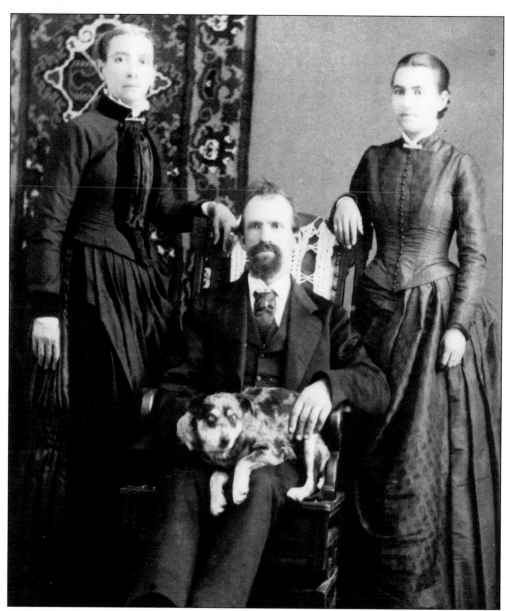

**JOHN MITCHELL FAMILY.** John Henry Mitchell (1840–1896) was a miner from Cornwall, England, who wandered into Helena by way of Michigan after the Civil War. There he met, courted, and won the hand of Martha Elizabeth Dunnam (left). In 1872, a daughter, Sarah Iola (right), was born. After serving two years as a warden in one of the convict mines near town, John tried his hand at farming. By 1880, he had grown tired of the Southern climate. His wife Martha, reminiscing years later wrote, "Papa got restless to go to California where he had a married sister and bachelor brother. The latter had had his leg broken in the Pennsylvania Mine shortly before, and papa wanted to help him." Later, Martha Elizabeth remembered that "Dad was crazy to sell the farm and go to California to take care of his brother. It nearly broke my mother's heart to leave her dear blind father who was 84 years old." The family moved. John and Martha Elizabeth both died in 1896 and are buried in Fresno, California. (Garland and Roberta Shinn.)

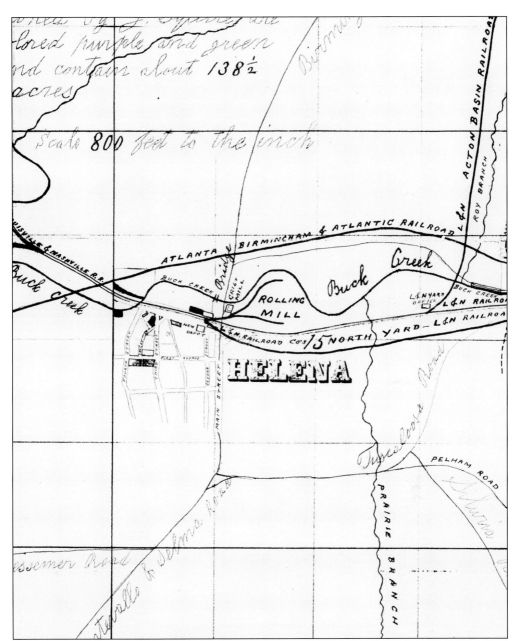

**JOSEPH SQUIRE'S MAP OF HELENA.** Joseph Squire loved to draw maps, and this particular one was probably completed shortly before his death in 1911. It clearly shows the network of railroads converging on Helena, as well as the large L & N yard just east of town and the spur line to the Acton mines. (Ken Penhale.)

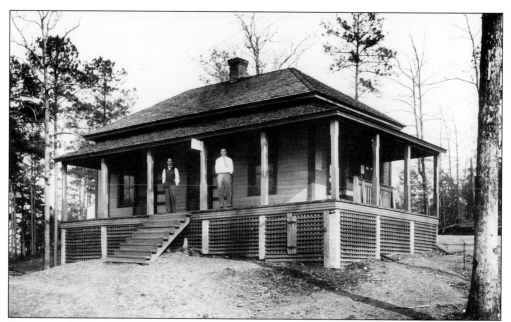

**COMPANY OFFICE, ACTON MINES.** Birmingham industrialist Henry DeBardeleben won and lost several fortunes in his lifetime. The Alabama Fuel and Iron Company was his last attempt at riches. Mining operations began at Acton, just north of Helena in the Riverchase area, about 1905. Other company mines were located at Overton, Acmar, between Leeds and Trussville, and Margaret, west of Odenville in St. Clair County. (Prince Debardeleben.)

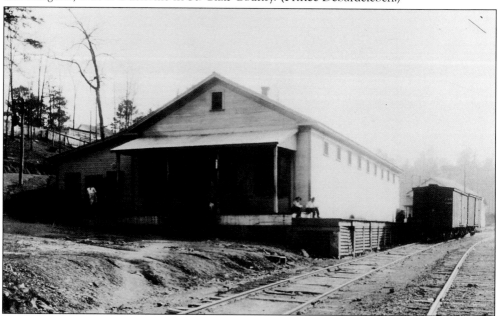

**COMPANY STORE, ACTON MINES.** When Henry DeBardeleben died in 1910, his son Charles assumed control. As was the common practice, miners were strongly encouraged to shop at the company store and to stay away from the United Mine Workers Union. Ed Barrington, a miner who often shopped at this store, was arrested on a charge of "dynamiting" during the 1908 strike. He was later acquitted. (Prince Debardeleben.)

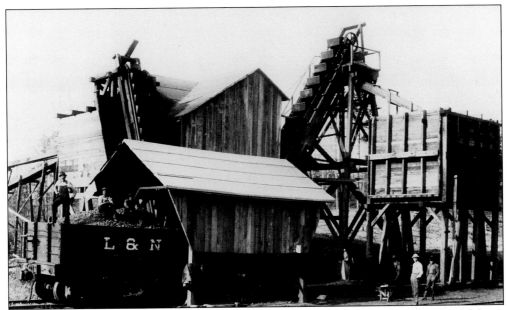

**COAL WASHER, ACTON MINES.** Despite periodic labor troubles, under Charles DeBardeleben's direction the Alabama Fuel and Iron Company prospered and by 1935 had the distinction of being the largest producer of commercial coal in Alabama. To ensure a uniform product, the company installed a washer to remove slate and other impurities from the coal at Acton. (Prince Debardeleben.)

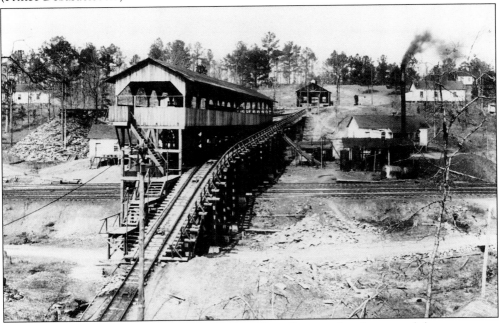

**ACTON COAL MINE #4.** Four coal mines were eventually opened at Acton, and they were some of the most dangerous in the state. An omen of bad things to come occurred in August of 1913 when, without warning, a rock fell from the roof of Number 3 mine, killing Nome Sealia, an Italian miner, instantly. Three months later, a terrifying explosion snuffed out the lives of 26 of the 43 men working in the Acton Number 2 mine. (Prince Debardeleben.)

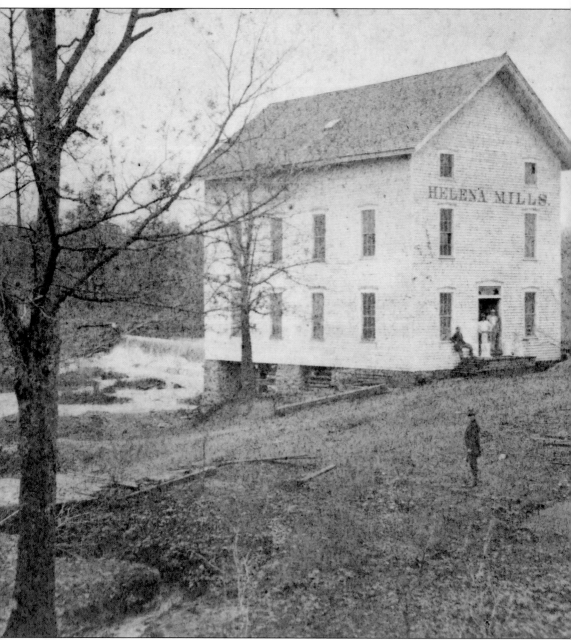

HELENA MILLS, C. 1878. Benjamin Franklin observed that gristmills were the connecting links between agriculture and industry. Gristmills were also often the beginning of a village or town. Progression from a millrace to a main street was a phenomenon that occurred all over America. A few other ingredients helped create Helena. The railroad, rolling mill, nearby coal mines, and the gristmill were the recipe that produced the town. Well before the Civil War, a gristmill operated in what would become Helena. Marauding Union troopers under General James Wilson took great relish in destroying the mill, noting the event in their diaries. In the mid-1870s, Richard Fell and Rufus Cobb reconstructed the gristmill at Helena. (Ken Penhale.)

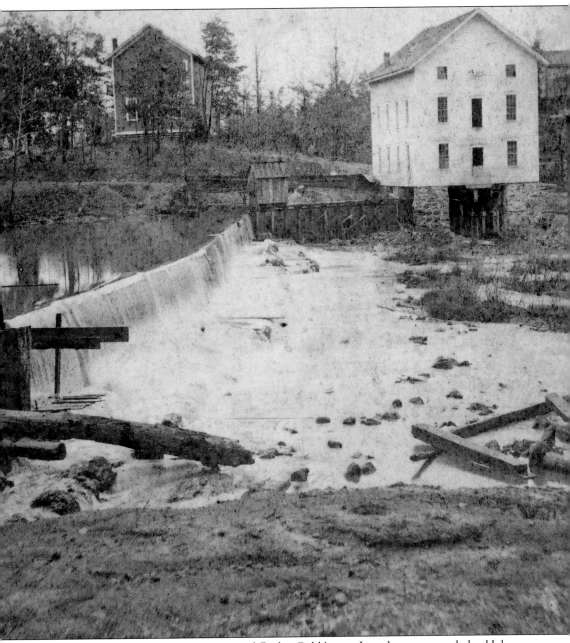

HELENA MILLS, C. 1878. C.C. Truss and Rufus Cobb's son Jonathan operated the Helena Mills. In 1882, they boasted they could grind 200 bushels of corn and 100 bushels of wheat daily. (Ken Penhale.)

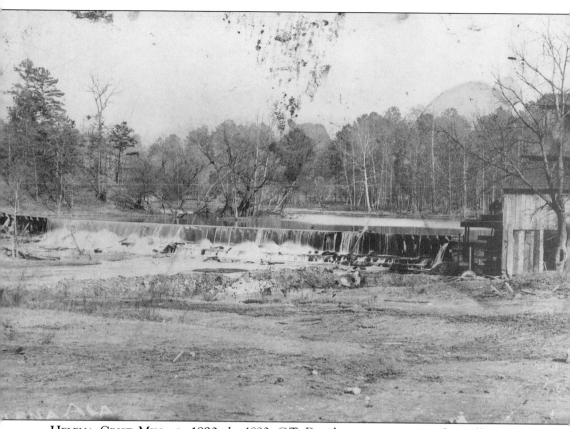

**HELENA GRIST MILL, C. 1890.** In 1890, C.T. Davidson was operating the mill at Helena. Sometime before, the mill of Cobb and Fell had burned. Davidson added a cotton gin but had yet to construct the concrete dam that exists today. (Alice Russell.)

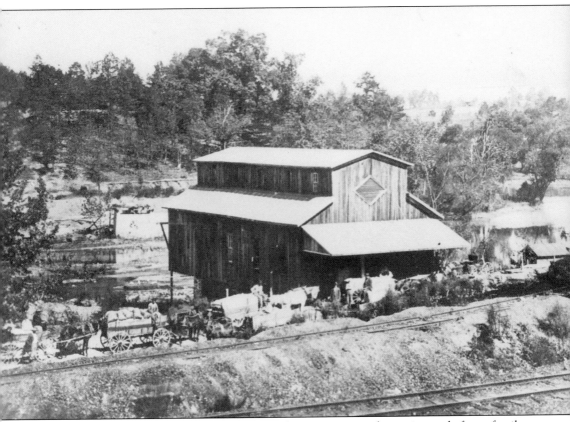

**HELENA GRIST MILL, C. 1910.** Taking cotton to the gin was a social occasion and often a family affair. Adults would discuss crops, weather, and the local gossip while children would wade or fish in the creek and mill pond. Underlying the gaiety of the event was a harsh economic reality. The welfare of the family in the coming year would depend on the price garnered for the cotton. To the left rear of the mill, the foundation of C.T. Davidson's electrical plant and the beginnings of the concrete dam can be seen. (Irene Mullins.)

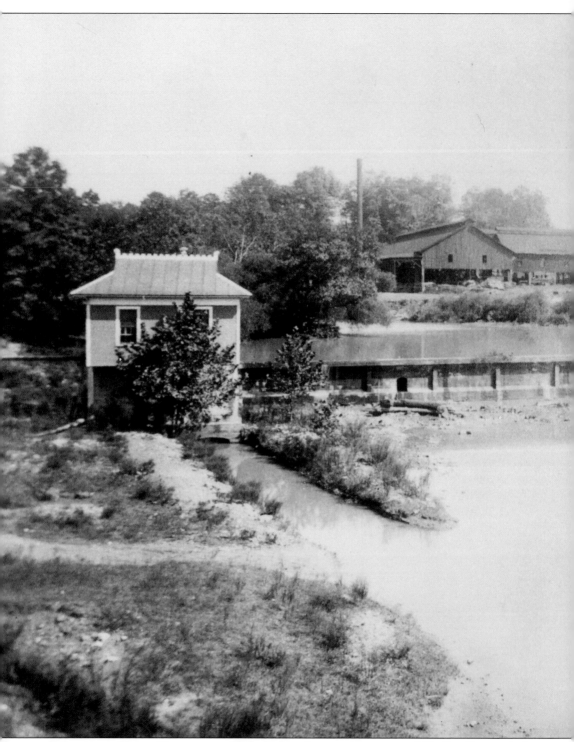

PANORAMIC VIEW, HELENA, C. 1913. Helena became the envy of Shelby County before
WW I. Conners-Weyman Steel Company produced 15,000 tons annually of hoops, bands,
and cotton ties; C.T. Davidson's turbines in the building on the left generated electricity,

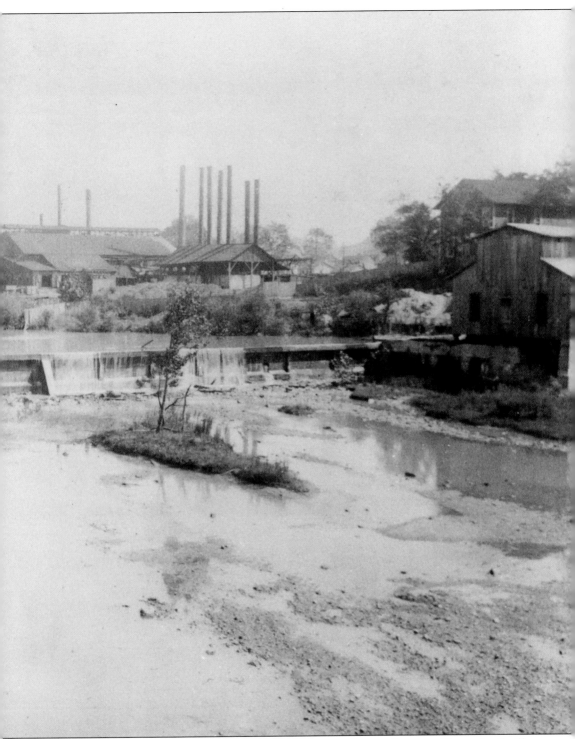

lighting the town while his mill ground corn and wheat and ginned cotton. To top it all off, this photograph was taken from the vantage point of a new iron bridge spanning Buck Creek. (Randy Robinson.)

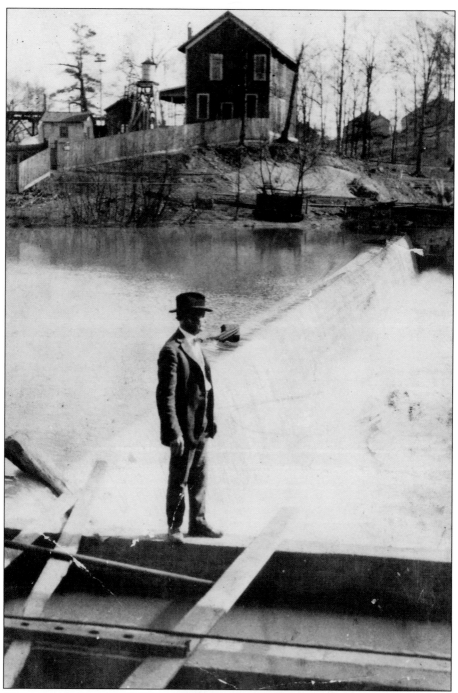

**C.T. DAVIDSON (1860–1926).** The son of John W. Davidson, C.T., or "Tom" as he was called, dabbled in everything. He constructed the existing concrete Buck Creek dam and built a reservoir to supply water to passing locomotives. He opened Helena's first telephone exchange and first electrical power plant. He operated a restaurant, public swimming pool, skating rink, and movie theater, as well as owning interests in coal mines, sawmills, and a mercantile store. For a time, C.T. Davidson *was* Helena. (Marion Davidson Sides.)

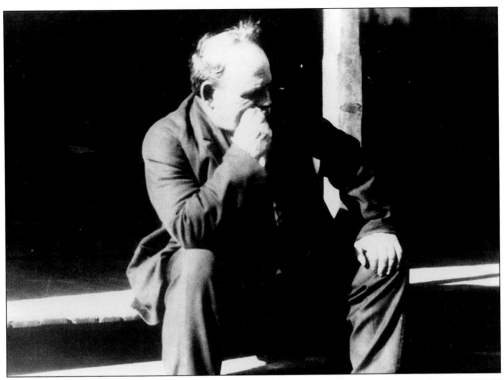

**JOHN BISHOP.** A native of Bibb County, Alabama, John Bishop (1847–1922) was very active in the Helena Masonic Lodge and a charter member of the Odd Fellows. At various times he operated the gristmill on Buck Creek in Helena. (Helena Masonic Lodge.)

**GEORGE WALLACE POSTELL.** A college-educated mining engineer, George Wallace Postell (1885–1944) spent the first five years of his career with the Roden Coal Company at Marvel. After a short stint with the Tennessee Coal, Iron & Railroad Company, he came to the Eureka Coal Company in 1914 as superintendent for George Conners, supplying coal to the rolling mill in Helena. When Eureka closed after WW I, he operated mines at Mossboro and Falliston. At the time of his death in 1944, Postell was stationed with the U.S. Army Corps of Engineers at Columbus, Mississippi. (Eleanor Postell Paty.)

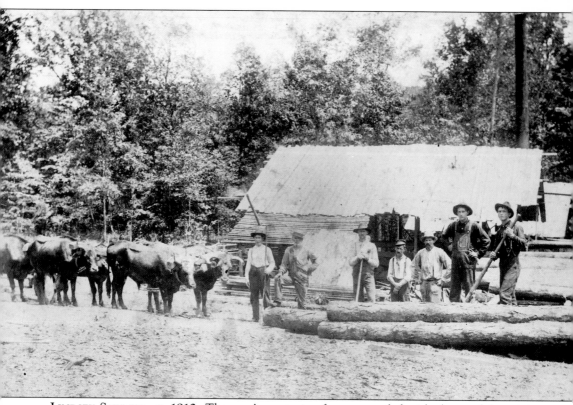

LINDSEY SAWMILL, C. 1912. The area's great pine forests, coupled with the need for mining props and lumber of all sorts, supported an important timber industry. Logs were hauled for miles on ox-drawn carts to a mill which could be a very dangerous place with exposed belts, pulleys, and unguarded blades 4 feet in diameter. Sylvester Steel Lindsey operated a sawmill just south of Helena. Born and raised on the Cahaba River in Shelby County, Lindsey's true gift, according to family legend, was estimating the value of standing timber. (Charles Griffin.)

# *Three*

# COMMERCE

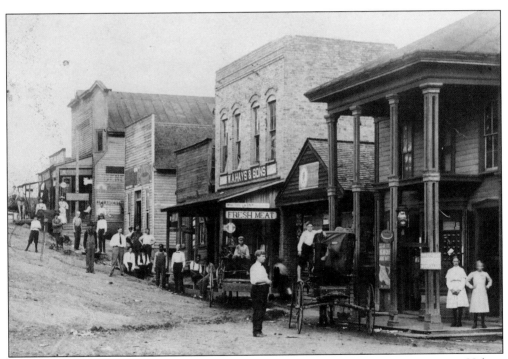

**HELENA'S MAIN STREET, C. 1910.** When the nearby coal mines were operating, Helena prospered and so, at the turn of the century, prospects were bright. By 1910, the town proper boasted a population of 450 including three doctors, W.A. Hayes, C.S. Strock, and J.F. Trucks. Mrs. J.A. Upshaw tended to the millinery needs of the community, and R.T. Gillam and T.L. Wallace ran meat markets downtown. Two livery stables competed for the horse and buggy trade, and the Ruffin Brothers, Lovelady, Harrison and Company, Walker and Company, and W.A. Hayes and Son eagerly vied for general mercantile customers. (Ken Penhale.)

57

**JOHN HOUSTON LOVELADY.** Born in Dogwood in 1865 and residing there until shortly after his marriage to Parry Lee Butler in 1889, John Houston Lovelady (1865–1954) burst on the Helena scene, opening a grocery store on Main Street. For 40 years, he sold foodstuffs and other goods, as well as operating a livery for a time. He took a leading role in the construction of the 1910 Baptist Church, where he served as clerk for many years. (Ken Penhale.)

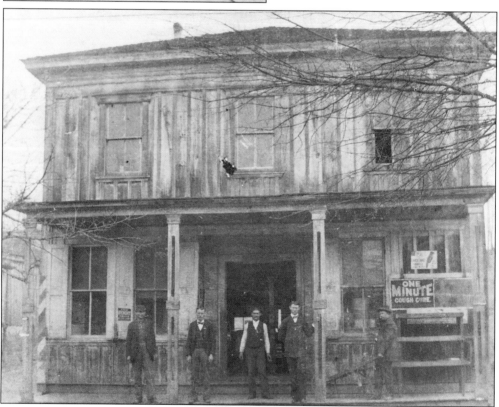

**L.P. LEONARD'S STORE.** L.P. Leonard was a prominent merchant in Helena around the 1880s. Later, in this same building, the International Order of Odd Fellows met upstairs. The Helena lodge was chartered in 1902. The original members were a list of "who's who" in town and included W.A. Hayes, John Penhale, James Bald, T.L. Wallace, R.T. Gillam, and M.E. Roy. (Ken Penhale.)

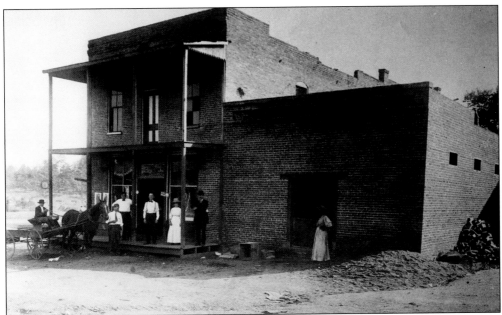

**BOWDEN'S STORE.** In 1912, Hayes and Bowden advertised that they were the "best and biggest" store in all of Shelby County and carried "a complete and up-to-date line of dry goods, clothing, hats, notions, hardware and farming implements" and "the best of everything in the grocery line." (Randy Robinson.)

**WALTER M. HAYES.** A son of Dr. W.A. Hayes, Walter M. was a partner in the Hayes and Bowden Store. The store's motto was, "Our Goods Give Satisfaction." (Helena Masonic Lodge.)

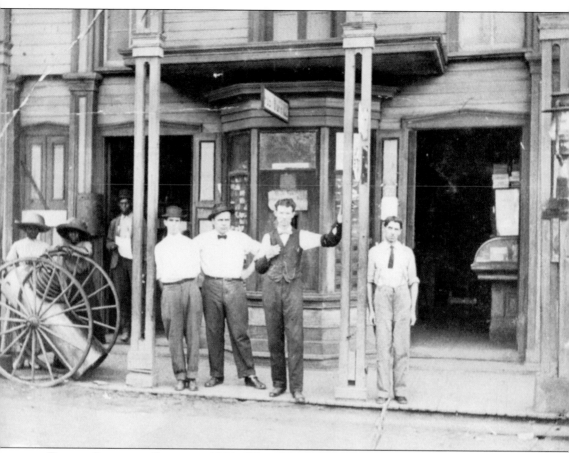

RUFFIN BROTHERS STORE, C. 1900. When J.L. Ruffin got off a train in 1878 and walked into downtown Helena, he undoubtedly had little notion that those steps were the beginning of a 50-year commercial dynasty. In February of 1879, the local paper noted in passing that J.L. Ruffin and sons (Lewis, Jefferson, and Emory) and R.B. Patton and J.D. Goode had recently opened stores. Located on the west side of Main Street next to the railroad, the Ruffin Store sold everything from hats to coffins and served as the town post office for many years. (Margaret Montgomery.)

**JEFFERSON DAVIS RUFFIN.** "Share and share alike" was the dying wish of J.L. Ruffin for his sons. He instructed them to keep no accounts on themselves and to take what was needed when needed. The arrangement must have worked. Jefferson Davis Ruffin (1861–1948) and his brothers remained in business longer than anyone in Helena, then or since. (Ken Penhale.)

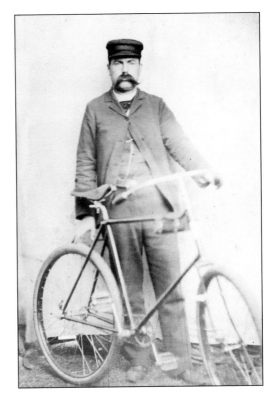

# J. D. RUFFIN,

## ≪Agent for the State of Alabama≫

### ⋯FOR THE SALE OF⋯

# Professor Ch. Fromm's Valuable Cider Receipts.

### OFFERS TO THE PUBLIC THESE WONDERFUL RECEIPTS FOR

# MANUFACTURING AND REFINING

# Sweet ⁜ Apple, ⁜ Pear ⁜ and ⁜ Grape ⁜ Ciders.

### IT IS THE GREATEST DISCOVERY OF ITS KIND OF THE AGE!

☞ I will assure each purchaser of this Receipt that it is NO CHEMICAL ADULTERATION, but the VERY ESSENCE of the fruit itself.

Last, but not least, it can be manufactured in ten minutes' time, at the minimum cost of nine cents per gallon. Who can beat it!

**J.D. RUFFIN CARD.** In addition to his mercantile business, Jefferson Davis Ruffin had a few side pursuits. He operated the Helena Bottling Works for a time and was the agent for Professor Fromm's cider recipes, a particularly valuable set of instructions with the advent of prohibition. (Ken Penhale.)

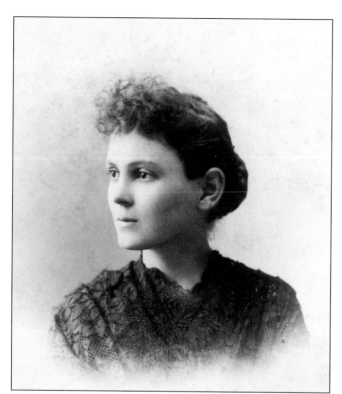

**CLAUDIA RUFFIN.** Jefferson Davis Ruffin married Claudia Alice Dunnam (1873–1934), the daughter of Thomas A. and Henrietta English Dunnam. (Ken Penhale.)

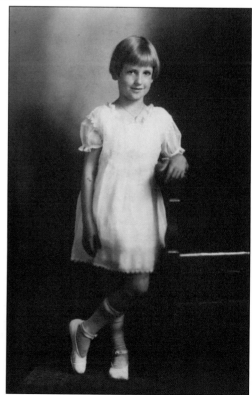

**MABEL ANN RUFFIN.** A daughter of Jefferson and Claudia Ruffin, Mabel Ann (1911–1995) became a nurse and married Norman L. Arnold. (Ken Penhale.)

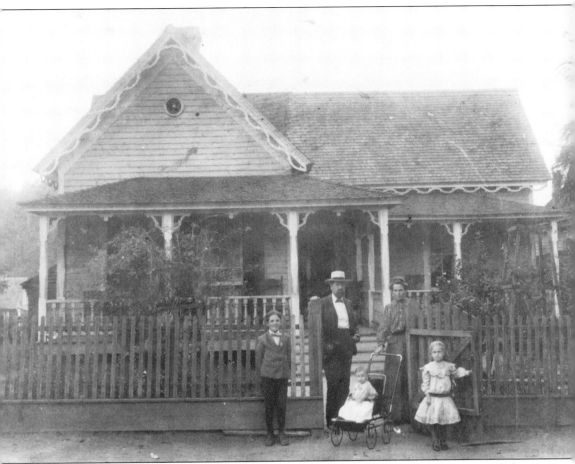

**JEFFERSON DAVIS RUFFIN FAMILY.** The Ruffin Store, despite casual bookkeeping, provided a good living for all the brothers. Jefferson Davis Ruffin and family posed in front of their fine residence on Second Street, a structure that was demolished in the 1950s. (Ken Penhale.)

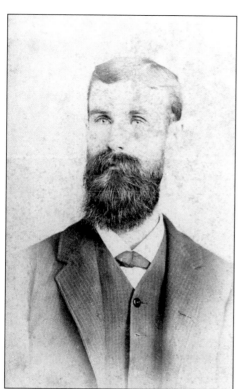

**J. EMORY RUFFIN.** Another of the Ruffin brothers, J. Emory (1856–1931) served as the town's postmaster. It was the custom of the Ruffin Store that if anyone bought an article on credit and then returned to pay for it, they would be referred to the brother that had originally sold them the merchandise. (Margaret Montgomery.)

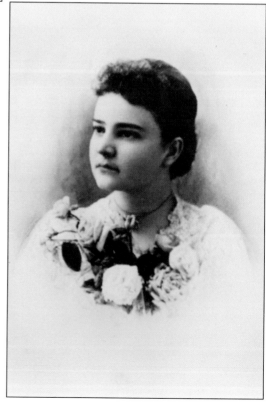

**MARGARET ECHOLS RUFFIN.** J. Emory Ruffin and Margaret Echols (1870–1957) had a large wedding in the Helena Methodist Church, where she was a charter member. (Margaret Montgomery.)

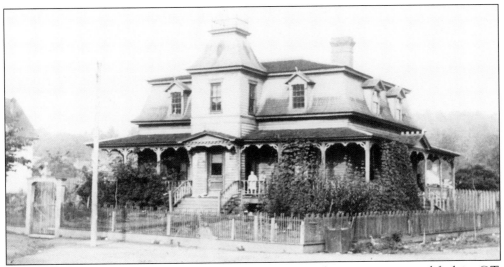

**C.T. Davidson House.** The exuberance of Helena's early years was exemplified in C.T. Davidson's home, not surprisingly one of the most imposing in town. Constructed in high Victorian style with mansard roof and delicate and intricate trim, it was a home fit for "Helena's prominent electric light and power plant, gin and mill owner." The structure, though greatly altered, still exists on Second Street, next to the railroad. The second story was destroyed by the 1933 tornado. (Irene Mullins.)

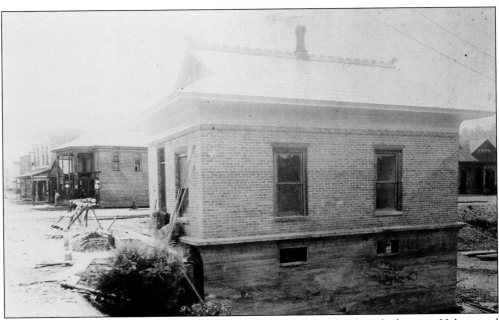

**Helena Telephone Exchange.** In 1913, C.T. Davidson brought the telephone to Helena and placed the switchboard in this building constructed specifically for that purpose. Merchants were thrilled and looked forward "to hearing the ring of the telephone bell" and seeing the rush of delivery wagons as they hurried to deliver the orders received over what was called a modern house convenience. In recent years, the building has been used as a jail and police headquarters. (Randy Robinson.)

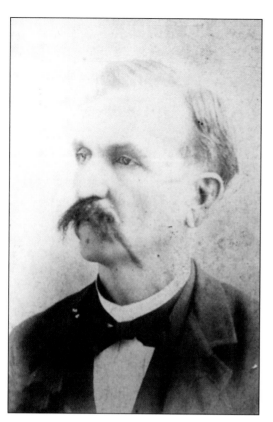

**DR. R.M. TUCKER.** Arriving in Helena around 1873, Dr. R.M. Tucker immediately began practicing medicine and, as was often the case with country doctors, also operated a drugstore. An astute businessman, Dr. Tucker noted that fortunes were being earned in the coal trade, and so, together with David Boazman, he found a small but profitable niche in the market selling coal and coke to area blacksmiths. (Pattie Lubright.)

D. J. BOAZMAN,                                      DR. R. M. TUCKER.

# BOAZMAN & TUCKER,

MINERS *and* DEALERS IN GLASCOW,

## BLACKSMITH COAL AND COKE,

The best in the State.

*HELENA, Shelby County, Alabama.*

Orders Solicited.

**BOAZMAN & TUCKER CARD.**

R.M. TUCKER AD.

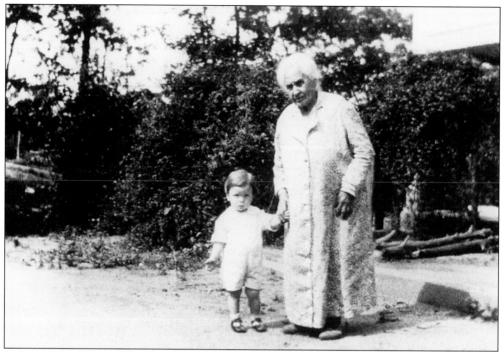

**MARY R. TUCKER.** Dr. Tucker's first wife was Julia Cotter. After her death he married her sister, Mary Davidson. Mary was the widow of N.C. Davidson, the brother of C.T. Davidson. The child in the photograph is Bill Tucker, Mary's great-nephew. (Ken Penhale.)

**TUCKER HOUSE.** Unlike so many of the other buildings in Helena, the Robert Tucker house survived the 1933 tornado. It was demolished in 1954. (Ken Penhale.)

**JOE L. TUCKER.** The son of Dr. R.M. Tucker, Joe L. Tucker followed somewhat in his father's footsteps, receiving a pharmacy degree from the state Agricultural and Mechanical College, now Auburn University. The portrait was taken in 1889, with Tucker wearing the cadet uniform of the college. (Dorothy Tucker.)

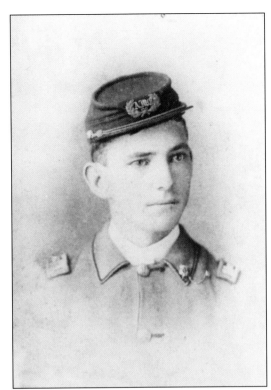

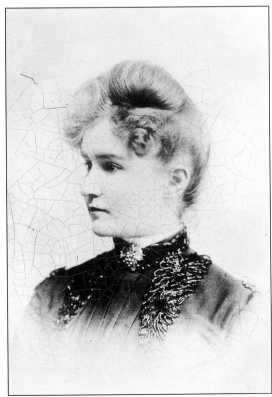

**ADA J. TUCKER.** Ada Cotter married Joe L. Tucker in 1889. After ten years of marriage and three children, Ada died, leaving her husband inconsolable. (Dorothy Tucker.)

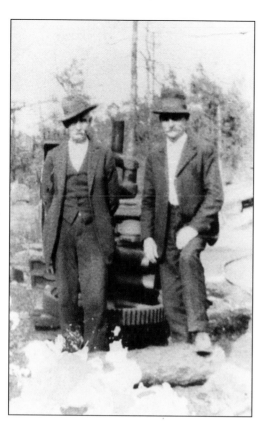

**JAMES BALD AND JOE L. TUCKER.** Joe Tucker became a tragic figure, never quite recovering from his wife's death. His father, Dr. Tucker, and his Aunt Mary raised his children, and he gave up pharmacy for house painting. The photograph was taken at the site of the old rolling mill, a place of many lost hopes and dreams. (Ken Penhale.)

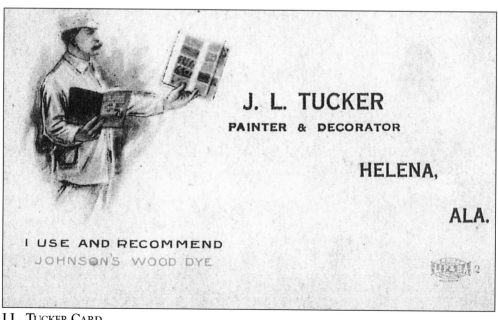

J.L. TUCKER CARD.

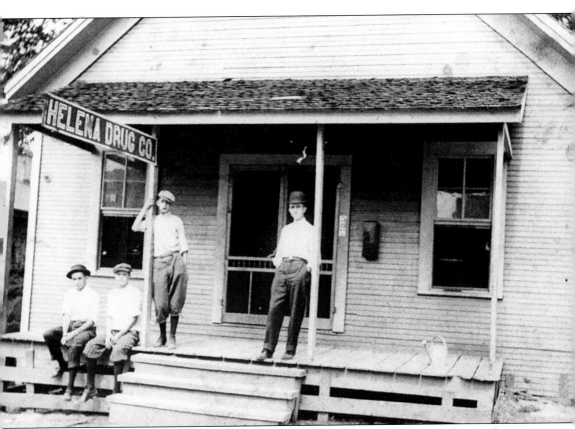

**HELENA DRUG STORE.** "Pure drugs, chemicals and fancy goods, toilet articles, perfumes, candies and standard patent medicine" could be purchased at the Helena Drug Company. From left to right, Robert Tucker, Newt Hubbard, and Fred Britton posed with the pharmacist, Dr. J.F. Trucks. Dr. Trucks was known as "a man of good habits and experienced through knowledge of his profession" who also ran a soda fountain inside with delicious and refreshing drinks and ice cream. (Ruth Naish.)

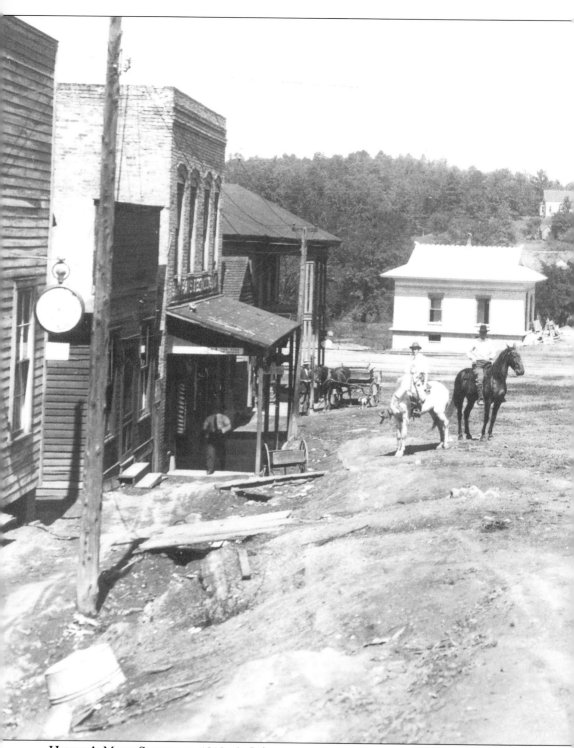

HELENA'S MAIN STREET, C. 1913. A Calera newspaper reporter visited Helena in February of 1913 and marveled at the many advances the town was making. "One time I spent the night there," he wrote, "and all the streets are in darkness, the next time it is a city of dazzling electric

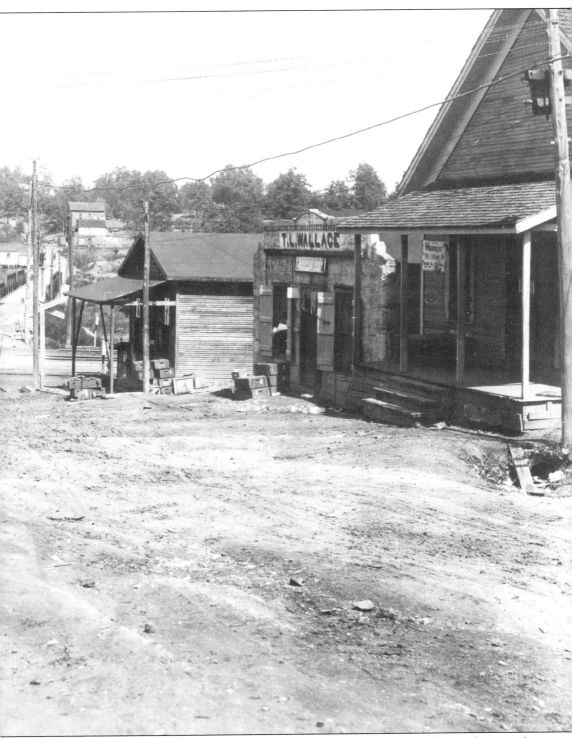

lights. The streets are being lined with telephone poles, wires are being stretched and a general every day city style rush and hustle exists among the trades people." (Randy Robinson.)

**Thomas R. Nash.** Like Joe Tucker, Thomas Nash (1892–1964) graduated from the state Agricultural and Mechanical College with a pharmacy degree. He had earlier attended school in Rome, Georgia. He moved to Helena around 1916 and purchased his first drugstore from Dr. Hayes. (Margaret Montgomery.)

**Rebecca Louise Nash.** As a new resident and young druggist in town, Thomas Nash could not have lost his heart to a girl with better family connections than Rebecca Louise Ruffin (1896–1992). She was the daughter of J. Emory Ruffin, one of the prominent merchant brothers of Helena. (Margaret Montgomery.)

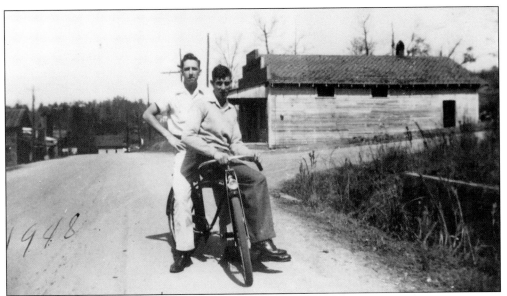

**NASH DRUG STORE.** In 1930, Thomas Nash built a new drugstore on the east side of Main Street, near the Masonic Lodge. Seven years later, he moved to Alabaster because of the declining economy in Helena. Pete Davidson and Paul Lovelace posed on an empty Main Street in 1948, in front of the Nash Drug Store. The building was torn down in the late 1950s and replaced with a brick building later used by the Helena Utility and Police Departments. (Lois McGlawn.)

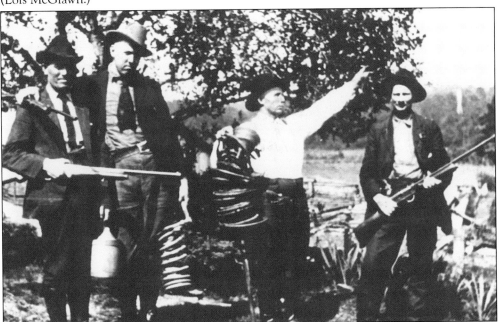

**WHISKY STILL.** Corn was a necessity around Helena, providing fodder for animals and bread for people. Next to cotton, corn was probably the area's best cash crop. But not all commerce involving the vegetable was legal. Its most valuable form was liquid, and moonshine stills dotted many of the nearly inaccessible hollows near town. Here, Jasper Roy and friends proudly display the ruins of a captured whisky still. (Bertie Roy Fox.)

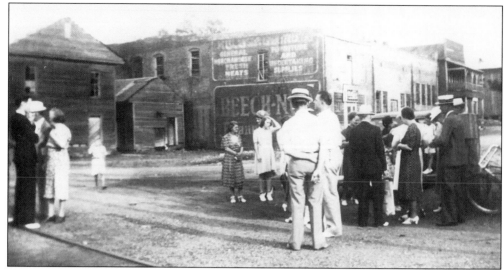

**WAITING ON THE TRAIN.** A good but unintentional 1940s view of the rear of Helena's Main Street stores can be observed in this photograph taken during a Pitts family reunion. The crowd was milling around the front yard of the C.T. Davidson home. After C.T. Davidson's death, his son, Joseph Squire Davidson, took up residence in the home place with his wife, Emmie Pitts Davidson. (Ken Penhale.)

**POWELL RESTAURANT.** A photograph of Frances Meade McLendon and Marie Bald around 1922 afforded a good glimpse of the first Powell Restaurant. Joseph Squire's daughter Clara and her husband Thomas were the proprietors, and later opened a larger restaurant and hotel in Helena. (Ken Penhale.)

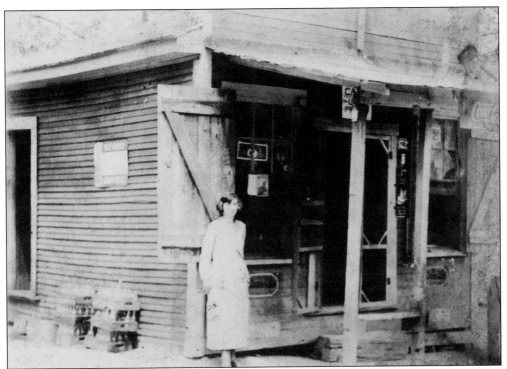

**MOORE'S STORE.** Small neighborhood stores were scattered throughout the town of Helena. The W.S. Moore family operated this one at the intersection of Main and Second Streets, across from the Presbyterian church. (Ken Penhale.)

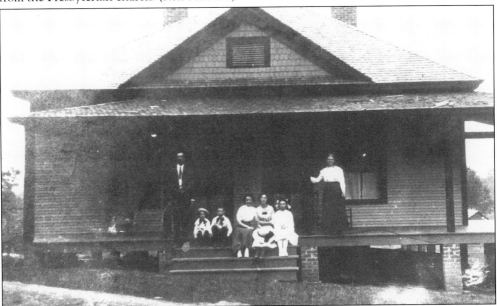

**MOORE'S HOUSE.** W.S. Moore and family proudly announced in the March 28, 1911 issue of the *Shelby County Review* that they were "looking to move into their new home soon." W.S. Moore later moved below Montevallo near Jemison, where he died in 1940. Luther Cross Mullins was living here when the house was destroyed by the 1933 tornado. (Ken Penhale.)

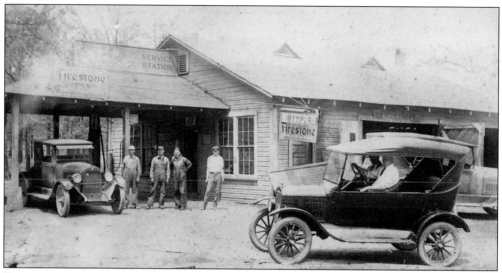

**FLOYD & FLOWERS GARAGE.** Around 1920, Ray Floyd, hoboeing on a freight train, saw smoke stacks in Helena and thought it might be a good place to find work. He jumped off, walked downtown, and talked a merchant into letting him have a pair of overalls on credit. Soon he was working for Conners Steel, where he met Robert Flowers. Within a couple of years, the steel mill closed, and Floyd and Flowers opened a garage with a complete machine shop specializing in Model "T" Fords. Floyd left the business before 1930 to run his father's farm in Columbus, Georgia. (Ken Penhale.)

**"TRUST YOUR CAR TO THE MAN WHO WEARS THE STAR."** Robert Flowers was employed by Atlantic Steel Company in Atlanta, Georgia, when he moved to Helena in 1920 to work in the Conners Steel Company machine shop. When Conners moved to Woodlawn, he commuted for a short time before opening Floyd and Flowers Garage, at the intersection of Main and Second Streets, with his friend Ray Floyd. Robert Flowers ran the garage until he was killed in an automobile accident in 1934. (Francis Flowers.)

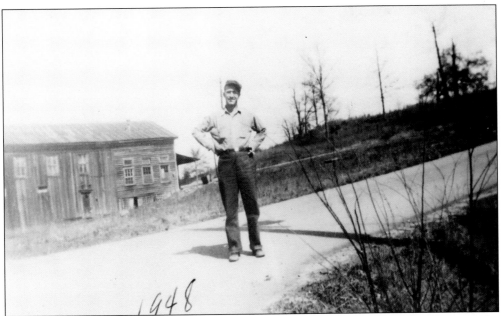

**ODD FELLOWS HALL.** The fraternal orders that flourished around the turn of the century in the area mining communities all but disappeared after WW II. The Masons maintained a strong presence in town, but the influence of the Odd Fellows waned. Albert Clark posed for this 1948 photograph in front of an unpainted and slowly deteriorating Odd Fellows Lodge. (Lois McGlawn.)

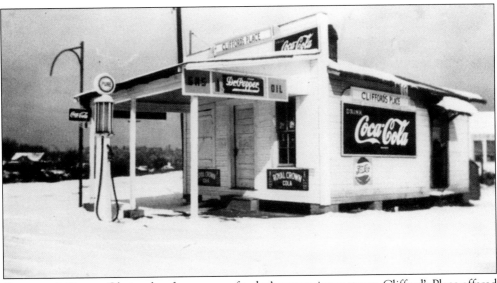

**CLIFFORD'S PLACE.** Obviously a forerunner of today's convenience stores, Clifford's Place offered one grade of gasoline and a variety of soft drinks. A Royal Crown Cola and a Moon Pie were in high demand at this store located at the intersection of County Road 52 and Main Street, now the Baptist church parking lot. (Ken Penhale.)

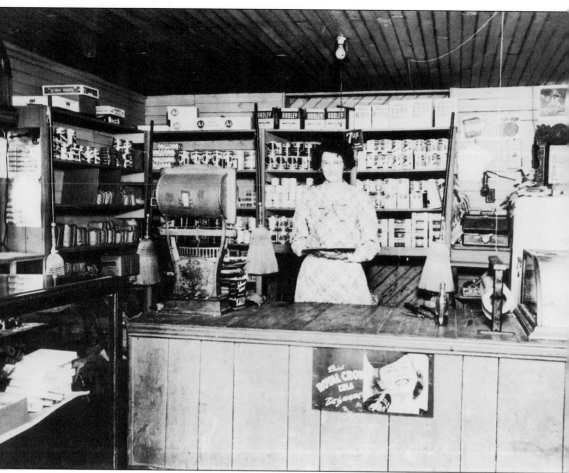

**ROY'S STORE.** In 1940, Eugene and Bessie Roy operated this neighborhood store located across from the Helena School. (Bessie June Dagley.)

**LUTHER AND NELLIE DAVIDSON MULLINS.** The Mullins brothers gave the Ruffin brothers a run for their money. There were four Mullins brothers who owned general stores in Shelby County, with three being in Helena. Luther Cross Mullins (1885–1953) first worked for his brother Gwin before opening his own L.C. Mullins General Merchandise Store on Main Street, which he operated for 37 years. (Kenneth Mullins.)

**FRED AND ETHEL LOVELADY MULLINS.** Another brother, Fred Ferguson Mullins (1882–1971), came to Helena about 1910. He married the daughter of Helena merchant John Houston Lovelady and ran a furniture and undertaking supply business in town. When the Depression and 1933 tornado devastated his property and business, he raised cattle and sold beef to the mining camps at Boothton and Marvel. (Patty Sue Donaldson.)

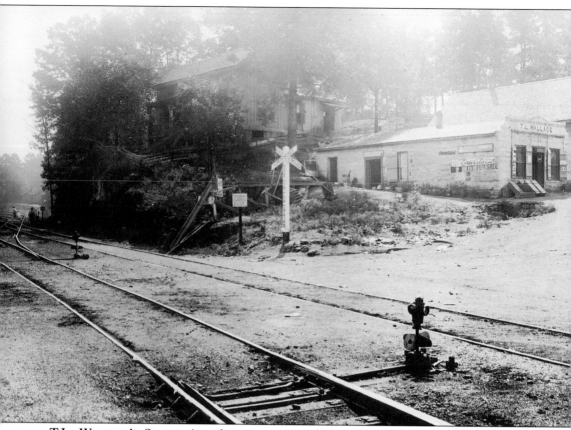

**T.L. WALLACE'S STORE.** An admirer commented that T.L. Wallace was an energetic and successful merchant who controlled his share of the enormous trade coming in from the different coal mines located near Helena. "He sells his goods right, wears a smile and invites his customers to come again." (Randy Robinson.)

# *Four*

# TRANSPORTATION

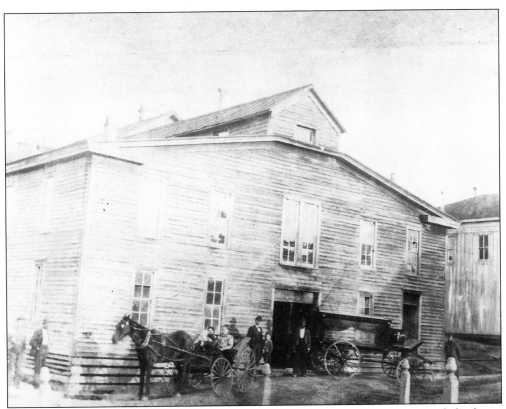

**LIVERY STABLE.** The horse and buggy required a variety of support services, and the livery stable was probably the most important. Not one to miss a business opportunity, C.T. Davidson operated this livery, located across the street from his home, around 1890. Here horses were boarded, buggies housed and repaired, and harnesses mended. (Ken Penhale.)

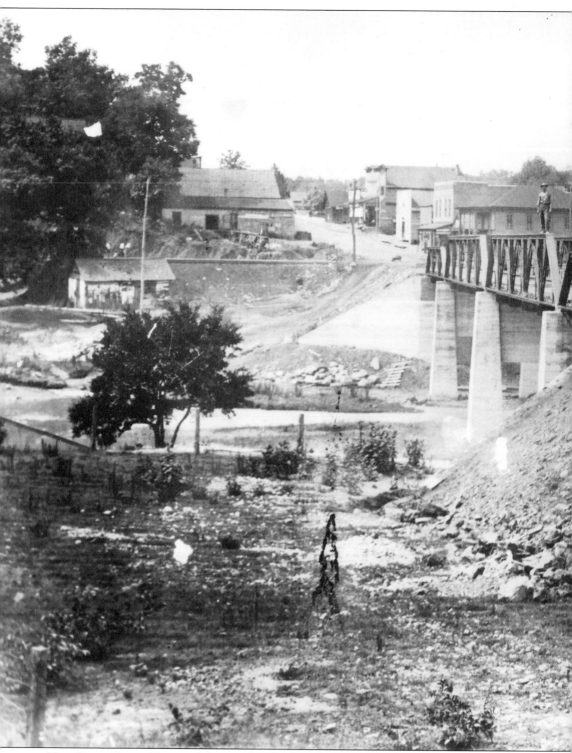

**NEW BUCK CREEK BRIDGE.** The people of Helena hailed the Shelby County Commissioner's Court decision in 1910 to construct a modern steel bridge across Buck Creek. The job was

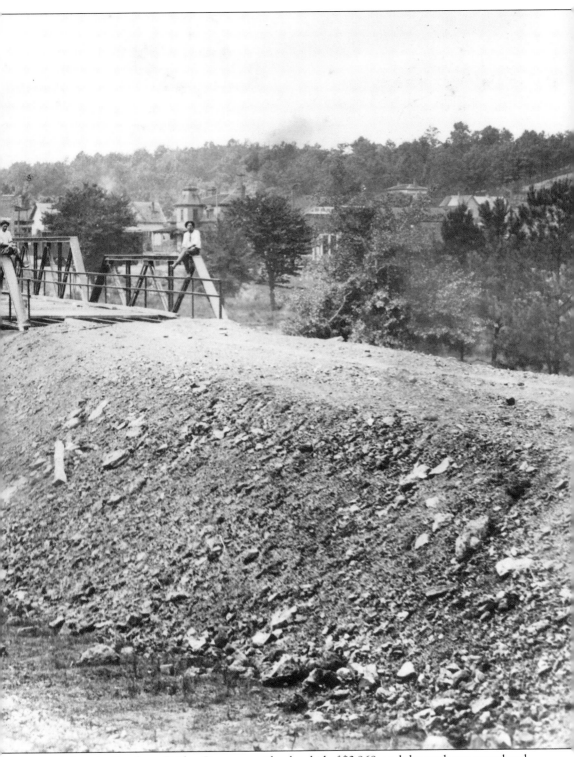

awarded to the Southern Bridge Company with a low bid of $3,968, and the work was completed in 1911. (Marion Davidson Sides.)

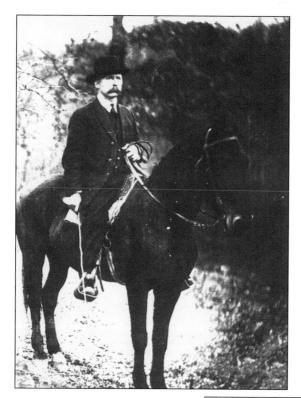

**JASPER ROY.** In 1915, railroads criss-crossed the state while the newfangled airplane pierced the sky and the well-to-do toured the countryside in modern automobiles. Despite these revolutionary changes in transportation, the horse was still important. Justice of the Peace Jasper Roy (1872–1929) lived just north of Helena on a large farm, where the Bearden dairy is now located. (Bertie Roy Fox.)

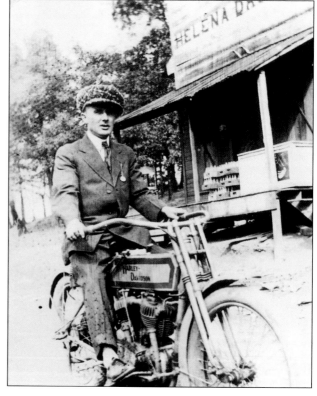

**RAY FLOYD.** Black leather jackets and knee-high boots had yet to become the attire of choice for Harley-Davidson riders around 1925. Ray Floyd was one of the first to own a motorcycle in Helena and is pictured here on Main Street in front of the c. 1875 Helena Drug Company building. (Ken Penhale.)

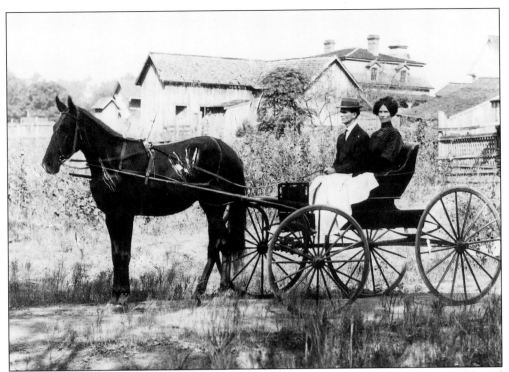

**ROBERT AND FORREST DUNNAM.** Ownership of a fine horse and buggy indicated wealth and a high social standing in the community. From left to right, Robert and Forrest Dunnam were obviously proud of both vehicle and animal. (Ken Penhale.)

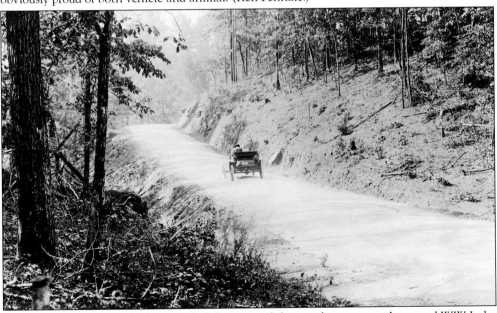

**BIRMINGHAM PIKE.** With the spread of the automobile into the countryside around WW I, the public demanded better roads. Though it would be decades before most rural roads were paved, improvements did take place. The Helena town fathers were proud of the Birmingham Pike, the main road north, as shown in this promotional photograph taken in 1913. (Randy Robinson.)

**FRANCIS FLOWERS WITH HIS FIRST CAR.** Francis Flowers was the envy of the neighborhood children when he took his first car for a spin in the front yard of his parent's house on Rolling Mill Street in 1923. (Francis Flowers.)

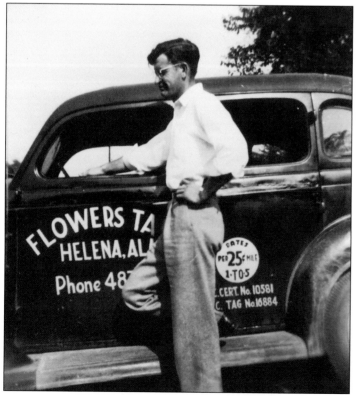

**FRANCIS FLOWERS, HELENA TAXI.** Francis Flowers and two Army Air Corps buddies purchased this car for $150 in Fort Wayne, Indiana, after WW II to get back to Alabama. Once home, Francis bought out the others' share and operated a taxi service. Saturday nights were busiest, shuttling partygoers over lonely roads to the outlying mining towns of Piper, Blocton, and Marvel. (Francis Flowers.)

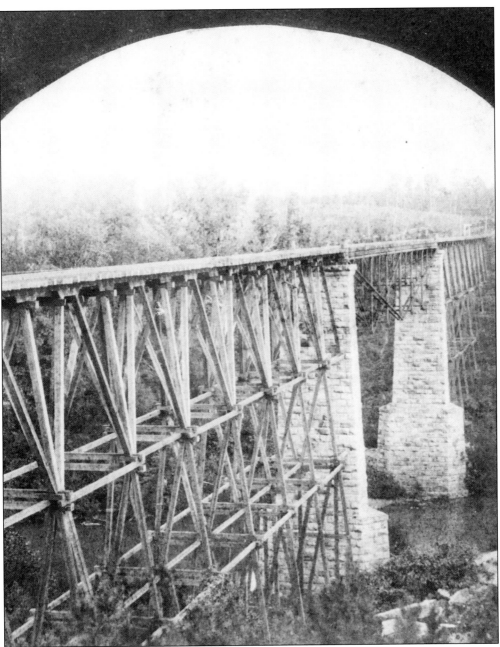

**SOUTH & NORTH ALABAMA RAILROAD BRIDGE.** The South & North Alabama Railroad bridge provided an easy river crossing for some rather unwanted visitors in 1865. General James Wilson and thousands of Union cavalrymen gingerly walked across this bridge beginning on March 29. An Iowa trooper, William Forse Scott, recalled seeing "a lattice bridge, high, with long trestle-work approaches at each end, and the whole built of wood." He remembered the "dull, slaty light of early morning in a driving rain, the swollen, rushing river, the high narrow bridge, the surrounding dark forest, the sharp orders of officers, with anxious outlook in fear that the enemy would appear on the opposite bank." No Confederates appeared, and eventually 10,000 Union troops crossed the bridge and rushed headlong through Helena. (Ken Penhale.)

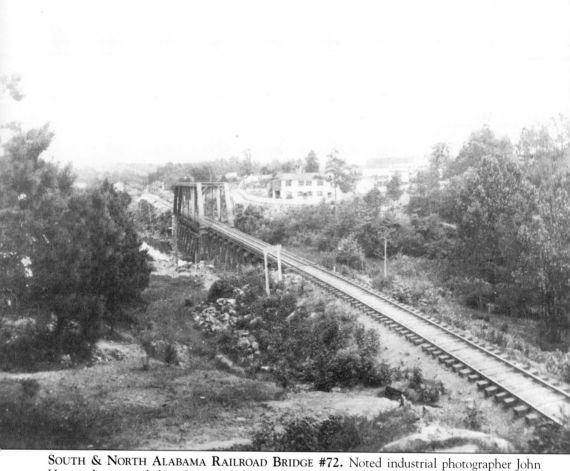

**SOUTH & NORTH ALABAMA RAILROAD BRIDGE #72.** Noted industrial photographer John Horgan Jr. snapped this photograph between 1887 and 1893, the years he operated a studio in Birmingham. Joseph Squire's house is in the middle of the image and just over the hill and unseen is the town of Helena. (Ken Penhale.)

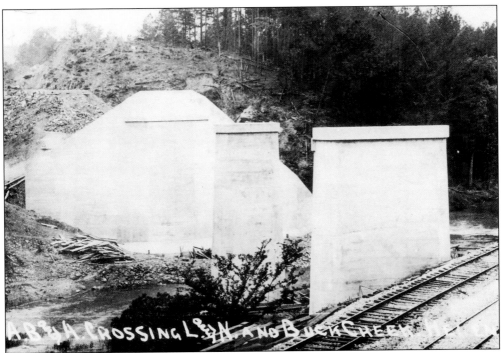

**AB&A RAILROAD BRIDGE.** In 1905, the Atlanta, Birmingham and Atlantic Railroad was incorporated by the original organizers of the Georgia Power Company with plans to operate a line from Brunswick, Georgia, to Birmingham by way of Atlanta. Within four years, crews were laying a mile and a half of rail a day while constructing this bridge over Buck Creek and the L&N's three tracks just west of Helena. (Ken Penhale.)

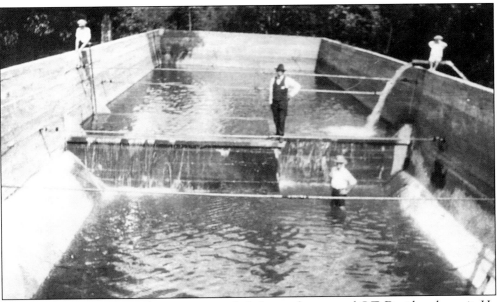

**AB&A RESERVOIR.** Steam locomotives needed plenty of water, and C.T. Davidson knew it. He built this reservoir to service the passing trains of the new Atlanta, Birmingham, and Atlantic Railroad. C.T. Davidson is standing in the center. (Ken Penhale.)

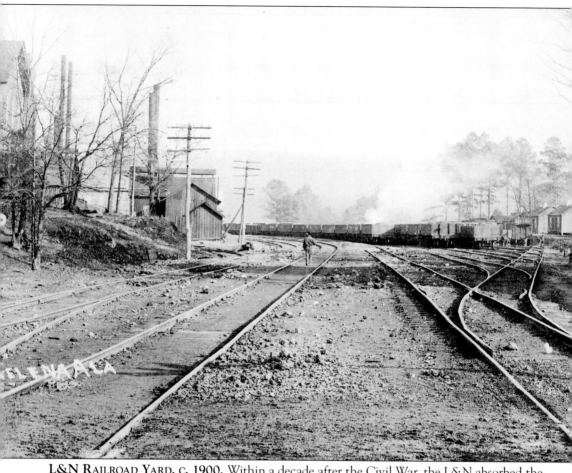

**L&N Railroad Yard, c. 1900.** Within a decade after the Civil War, the L&N absorbed the South and North Alabama Railroad to gain access to the rich mineral lands of the southern Cahaba coal field. By 1890, the L&N had a large yard at Helena to service the nearby coal mines and adjacent rolling mill. (Ken Penhale.)

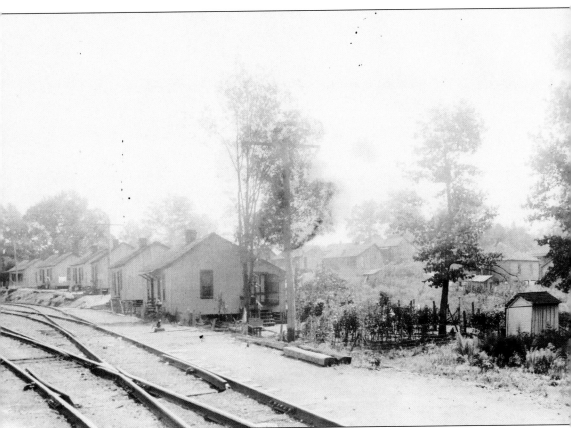

**L&N RAILROAD SECTION HOUSES.** The miles and miles of track and many bridges of the L&N required constant maintenance. Crews were boarded in section houses at strategic points along the line. These particular houses were just a stone's throw south and east along the track from Main Street. (Randy Robinson.)

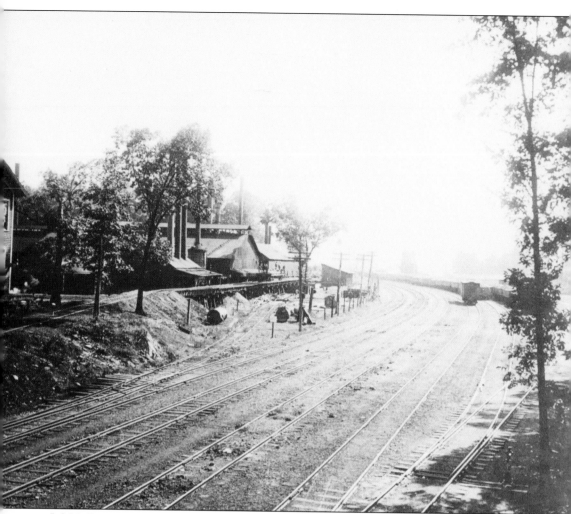

**L&N Railroad Yard, c. 1913.** The L&N transported most of the coal mined around Helena. The yard east of town was a dizzying maze of tracks and switches from which area coal would find its way north and south to be used in the fireboxes of almost all the railroads in the South. The tons of coke produced in the hundreds of bee-hive ovens near town wound its way along the L&N tracks to feed the blast furnaces that had proliferated near Birmingham. (Randy Robinson.)

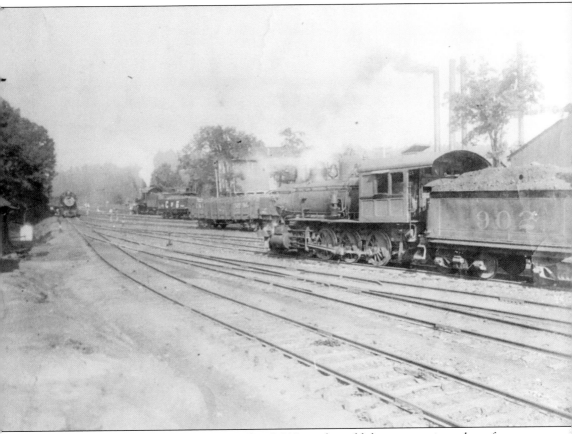

**L&N Railroad Switch Engines.** The L&N yard could be a tempting place for an adventuresome lad to catch a free ride. Bob Davidson, the son of C.T., tried to swing a train here the morning of May 23, 1910, missed and was thrown forcibly to the road bed. The heel of his shoe was caught under the wheels and wrenched from his foot. Other than hurt pride and a few slag cuts however, he survived. (Randy Robinson.)

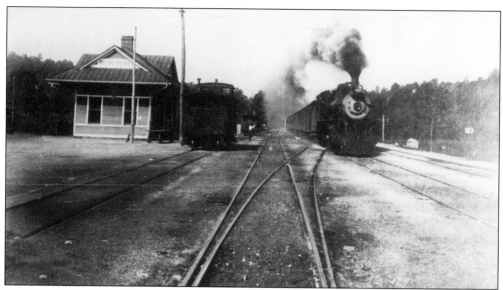

**HELENA DEPOT.** The depot was the gateway to the outside world. The mail and newspapers arrived there, as did goods and merchandise for the town's stores. From the Helena Depot on the L&N, people could travel anywhere in the United States, and the depot was often the first thing people saw of Helena. (Randy Robinson.)

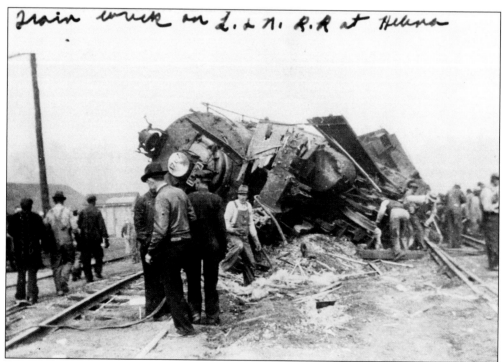

**TRAIN WRECK.** The depot could be exciting beyond any normal expectation. In 1940, two freight trains collided in front of the depot, causing this spectacular wreck. (Ken Penhale.)

# Five

# LATER FOLKS
# AND FAMILIES

BEATRICE AND JOHN EDWARD PENHALE. A diverse population was attracted to Helena while the coal industry prospered. Many of the skilled jobs were filled by experienced miners and engineers from England. The parents of Beatrice and John Edward Penhale were from County Cornwall. The children were photographed in 1878 at the Penhale residence on Rolling Mill Street. The father, William Henry Penhale, superintended various mining operations throughout the Cahaba and Warrior coal fields during his 45-year career. (Ken Penhale.)

**CHARLES AND EULA MAE HINDS.** Charles Hinds moved to Alabama about 1903 from Coal Creek, Tennessee, and began working at the Superior mines near Boothton, where he married his wife, Eula Mae. After working at Imogene, Coalmont, and Red Ash, he moved to Helena in 1912. In 1917, Hinds became Helena's mayor. (Ken Penhale.)

**HINDS' HOUSE.** Charles Hinds did well as a miner, and his experience and talents earned him positions of responsibility such as foreman and fire boss. Those positions and the salaries that went with them allowed him to build this residence, one much nicer than the average miner's house, in 1914. (Ken Penhale.)

**JOHN BRITTON.** The grandson of early settler Henry Lee, John Britton (1867–1933) was a steam engine operator at area coal mines. (Ruth Naish.)

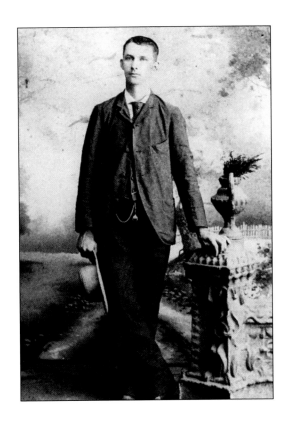

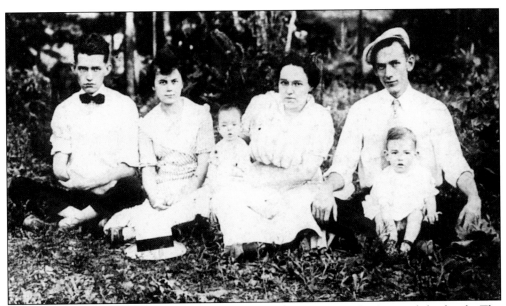

**FAMILY PICNIC, C. 1916.** For most Helena residents, social life revolved around the family. The Brittons and Kirbys were related by marriage and took advantage of a picnic to renew family ties. Pictured from left to right are: Fred Britton, Kathleen Echols Britton, Ruth Kirby, Will Britton Kirby, Frank M. Kirby, and Josh Frank Kirby in lap. (Ruth Naish.)

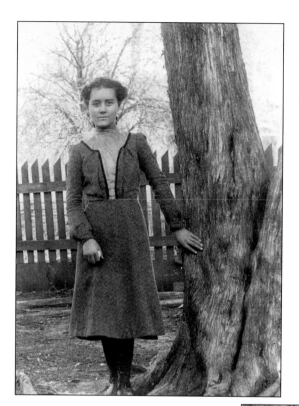

**LUCILE C. WYATT.** A descendant of two of the earliest families in the Helena area, the Wyatts and Griffins, Lucile C. Wyatt (1889–1970) married James M. Wooten, a mechanic and taxi driver. (Charles Griffin.)

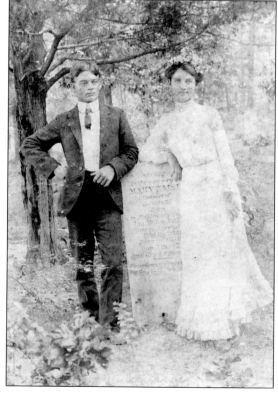

**GEORGE AND CLORA COOK McGLAWN.** George and Clora Cook McGlawn lived together in Helena several years after their marriage at Cullman on October 30, 1901. George was a photographer and set up shop in towns around north and central Alabama. He died in Gadsden, a victim of the flu epidemic of 1918. Clora returned to Helena, remaining a widow for 59 years. (Lois McGlawn.)

**VIRGINIA BEGGS MURPHY.** With her blind husband Will, Virginia served as the Helena depot agent. She was the granddaughter of Hamilton T. Beggs, who established the first foundry and machine shop in the new city of Birmingham. (Ken Penhale.)

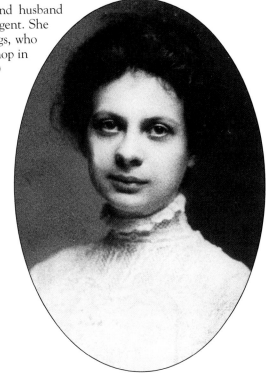

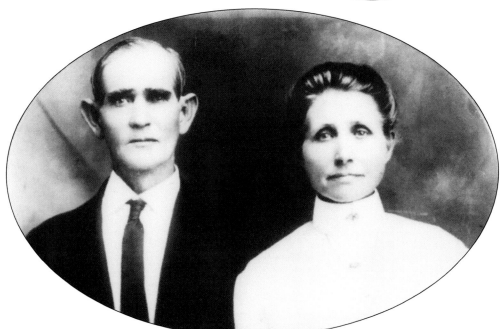

**GEORGE AND SARAH ELIZABETH NAISH.** Though mining was the dominant industry around Helena, farming was always important. George Shelby Naish was a farmer, though he and his wife supplemented their income with a store and boardinghouse located at the corner of First Avenue and Second Street. (Floyd Naish.)

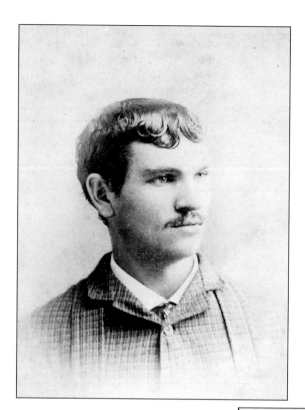

**CHARLES LEONARD DUNNAM.**
Charles Leonard Dunnam (1865–1921) was the youngest son of Robert Thomas Dunnam, and he remained on the family farm with his parents until their deaths. (Martha Patridge.)

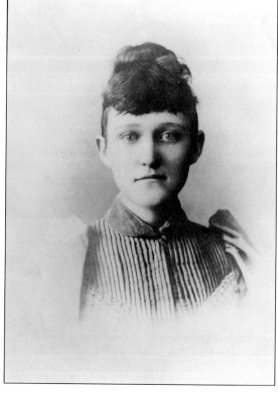

**MARTHA ELLA ROSS DUNNAM.**
Charles married Martha Ella Ross Dunnam (1873–1963), and they had 11 children. According to family tradition, Martha's father, Andrew Campbell Ross, furnished and hauled the lumber used to build the first Presbyterian church in 1850, in what would become Helena. (Martha Patridge.)

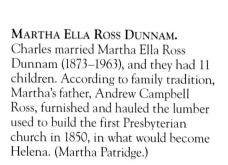

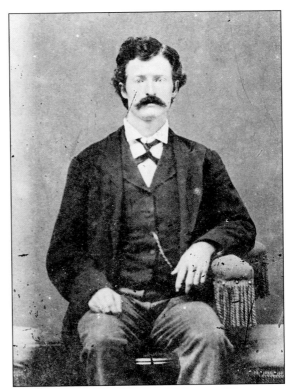

ROBERT THOMAS DUNNAM. Born and raised in Tallapoosa County, Alabama, Robert Dunnam (1824–1896) moved to Shelby County as a young man and purchased a farm at what was then Hillsboro. The Dunnam children were Thomas Allison, Mary Lucinda, Susan Ann (who married a son of Governor Rufus Cobb), William Andrews, Frank Pickens, and Charles Leonard. (Charles Dunnam.)

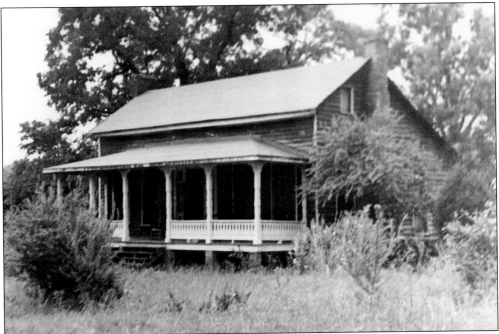

DUNNAM HOUSE. In 1867, Robert Dunnam acquired what was called the Meredith place from Elias and Mary M. Meredith McClellen, and moved his family into this house, which was probably built about 1845 by Robert Bratton, an early resident from York County, South Carolina. Robert added a cotton gin and press to the property. (Martha Patridge.)

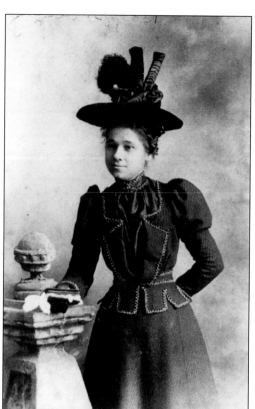

**WILLIE ARMSTEAD RANSON.** The daughter of John and Viola Davidson Ranson, Willie Armstead Ranson married Dr. Floyd, who practiced medicine in Helena before moving to Fort Payne, Alabama. Willie was the niece of the indomitable C.T. Davidson. Her father worked for the railroad. (Ken Penhale.)

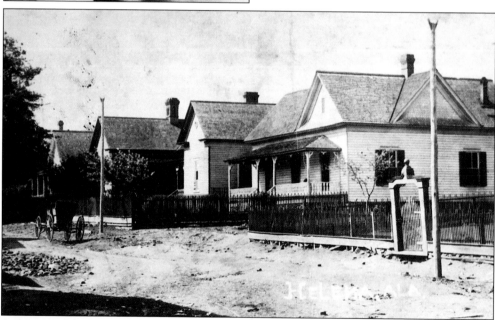

**A MATCH MADE ON SECOND STREET.** A 1900 postcard of Helena portrayed an idyllic small-town scene, with Dr. Floyd's house in the right foreground and the Ranson house next door. The love-smitten couple courted across the fence separating their respective front yards. (Ken Penhale.)

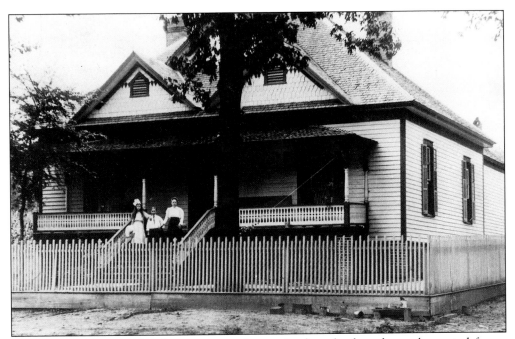

**W.S. ESCO FAMILY.** Before laws requiring farm animals to be fenced, people erected fences around their homes to keep pigs, cattle, and goats from wandering into their yards. The W.S. Esco family was photographed about 1910 in front of their animal-proof house located next to the Helena School. (Ken Penhale.)

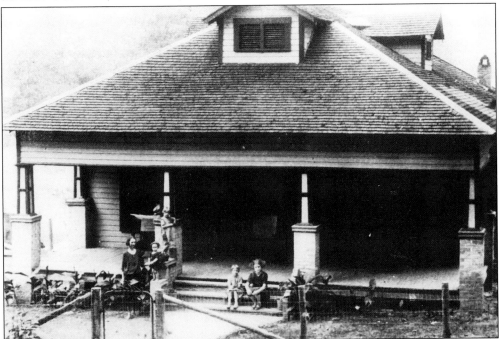

**HILLARY SWEAT FAMILY.** Another well-to-do miner, Hillary Sweat moved to Helena about 1910. Pictured from left to right are: Hillary's wife, Myrtle, and children, Flynn, Florence, and Junita, with a friend, Eundora England. (Flynn Sweat.)

**DR. FRITZ R. LUBRIGHT.** There may have been a little suspicion in the community about the new German dentist, Dr. Fritz Lubright (1883–1941), when he first moved to Helena during WW I. Those doubts, however, were quickly dispelled, and he became a popular dentist with offices in Helena and the nearby mining towns of Marvel and Piper. (Ken Penhale.)

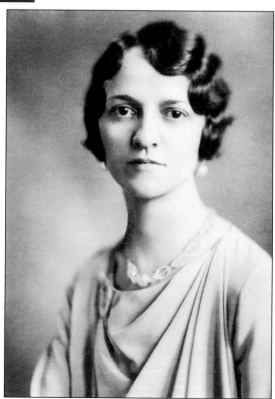

**PATTIE TUCKER LUBRIGHT.** Dr. Lubright cemented his place in Helena society when he married a local girl, Pattie Tucker (1895–1984), the daughter of Joe L. Tucker. (Dorothy Carlisle.)

106

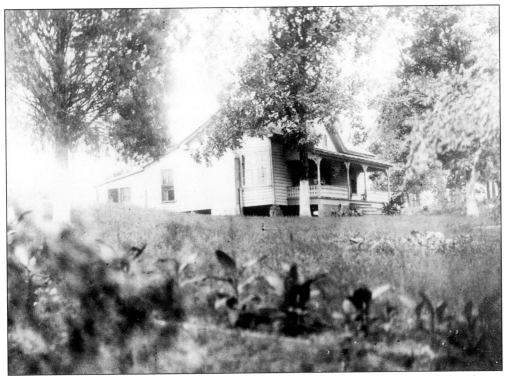

**LUBRIGHT HOUSE.** The Lubrights were sound asleep when the tornado destroyed their house a little past 3 a.m. on May 5, 1933. Pattie's Aunt Mary was in an adjoining room, and miraculously no one was hurt. Twelve people were killed that morning in the darkness. (Ken Penhale.)

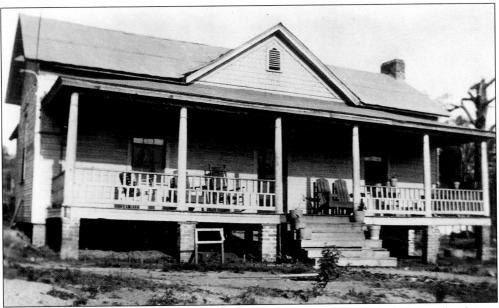

**M.E. ROY HOUSE.** The Roy family has lived in this house across from the Helena School since 1928. (Margaret Flowers.)

**J.L. DAVIS HOUSE.** Welsh miner J.L. Davis (1839–1902) built this home about 1888 on Rolling Mill Street. He planted 1,000 pear trees nearby, hoping for a ready market for his fruit in Birmingham. The house was destroyed in the 1933 tornado. (Ken Penhale.)

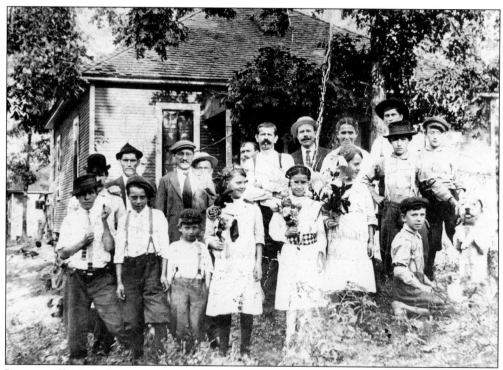

**LUDWICK FAMILY.** A German family, the Ludwicks, moved to Helena seeking work in the coal mines. They lived over the hill behind the Masonic Lodge, and in this photograph appear to be gathered for some sort of spring celebration that included the family dog on the far right. (Ken Penhale.)

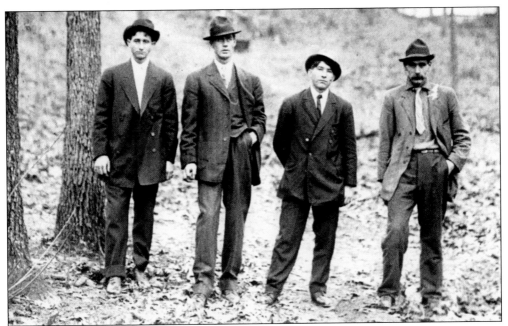

**DUDES, C. 1915.** In what could have been an ad for the Ruffin Brothers haberdashery department, from left to right, Charlie Sweat, Charlie Hinds, Hillary Sweat, and Mr. Dumbroski, all miners, took time out to be photographed in 1915. (Ken Penhale.)

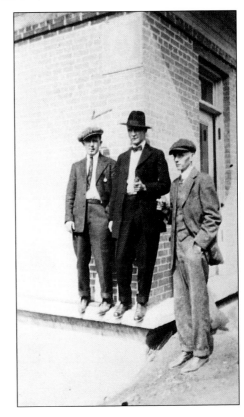

**LATER DUDES, C. 1920.** Street corners seem to attract young men with nothing particularly important to do other than talk, smoke a cigarette, and watch the world go by. Checking things out in front of the telephone exchange, from left to right, are: Ray Floyd, Sam Hawkins, and Harmon Davidson. (Ken Penhale.)

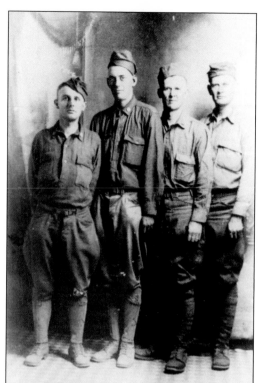

**DOUGHBOYS, 1918.** Patriotism ran rampant around Helena when the United States entered WW I. Pictured from left to right, Ray Floyd, Tom Griffin, Tom Nash, and Jack Griffin answered the call to arms and posed for this photograph in 1918 prior to being shipped to France. (Charles Griffin.)

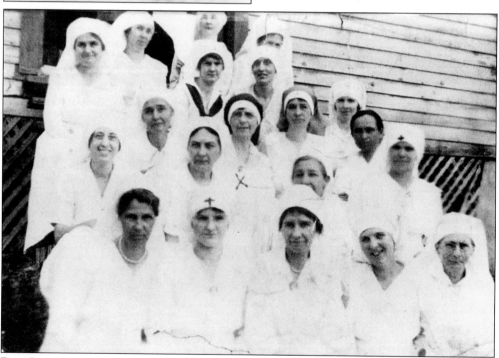

**RED CROSS VOLUNTEERS, C. 1918.** The women left behind also did their part and volunteered for service with the Red Cross, where they learned rudimentary nursing skills. Girtie Lee, the daughter of early settler Edward Lee, is in the center of the photograph. (Ken Penhale.)

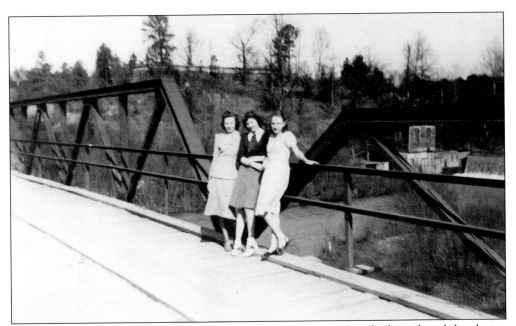

ON THE BRIDGE, 1948. In the first half of the 20th century, Helena had weathered the closing of its major industries, the Depression, a devastating tornado, and two world wars, and in 1948 was a sleepy little town where, from left to right, Lois England, Margaret Clark, and Clytie England could pose on the main one-lane bridge without fear of traffic. (Lois McGlawn.)

WAITING FOR THE SCHOOL BUS, 1948. In 1948, the future seemed bright for Alice Pless and Bill Tucker as they waited for the school bus. Tucker later joined the Marine Corps and retired as a major. (Lois McGlawn.)

**EMMIE PITTS DAVIDSON.** Joseph Squire Davidson left the confines of Helena to find himself a wife, marrying Emmie Pitts of Columbiana in 1929. Emmie had been the assistant of the Shelby County Tax Collector and once in Helena taught school and served as the town clerk. She was an original member of the county library board. (Marion Davidson Sides.)

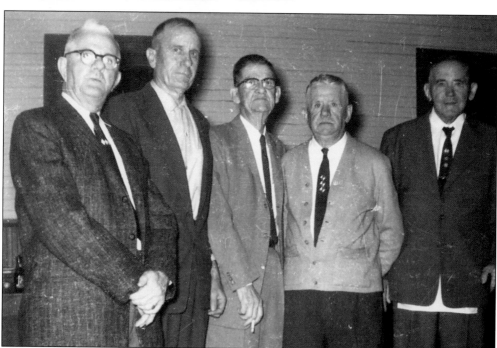

**LODGE MEETING, 1959.** Still going strong after 83 years, the Helena Masonic Lodge included many of the prominent men of the town including Tommy Wallace, Johnny Gates, Tom Nash, Jack Davidson, and Eugene Roy. (Ken Penhale.)

# *Six*

# CHURCH AND SCHOOL

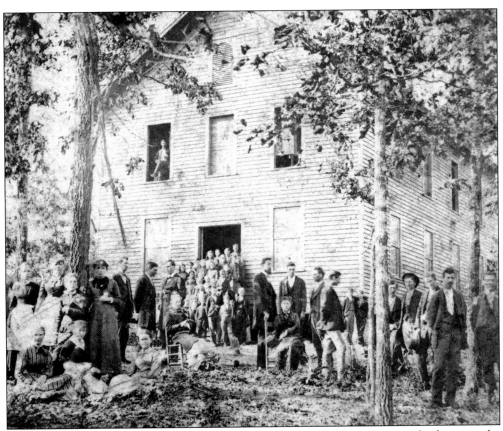

**HELENA MASONIC LODGE.** The Helena Masonic Lodge Number 410 was chief among the several fraternal orders organized in Helena. Charter members in 1876 included William B. Cross, Albert Webb, Thomas J. Winfield, J.L. Davis, David J. Boazman, John W. Davidson, Alfred F. Johnson, and Rufus W. Cobb, the first Worshipful Master. (Ken Penhale.)

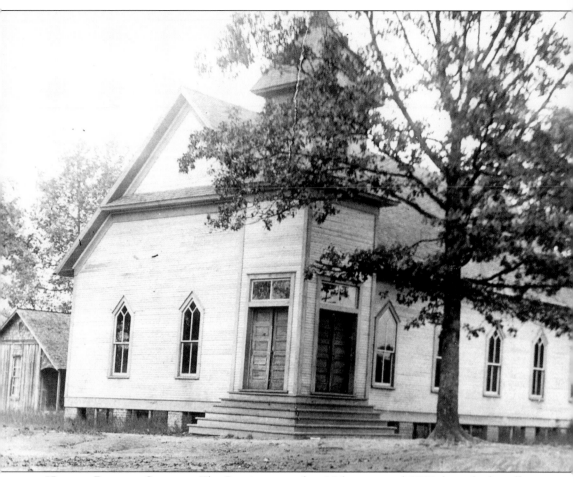

**HELENA BAPTIST CHURCH.** The Baptists moved to Helena around 1877 through the efforts of the Cobb and Fell families. Previously, a church known as Union had existed about 5 miles south of town. Initially, the congregation worshipped on the first floor of the Masonic Lodge. About 1910, a sanctuary was built near the present Baptist church, but it was destroyed in the overall devastation of the 1933 tornado. Early ministers included the Reverends Lee, Taul, Martin, Adams, Wood, Crowder, Cook, Wyatt, and Nunnally. (Ken Penhale.)

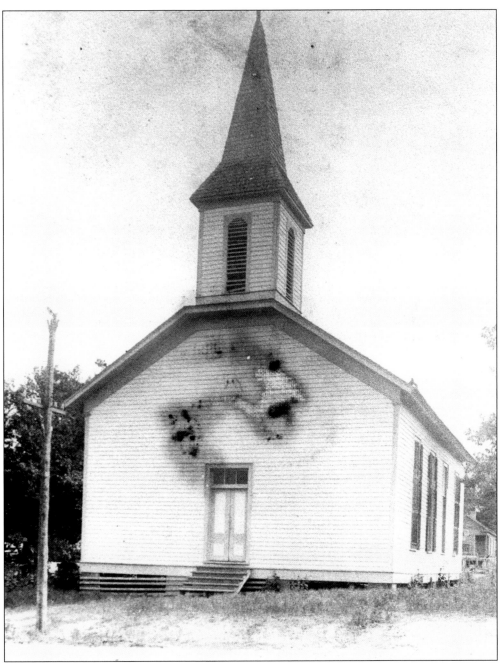

**HELENA METHODIST CHURCH.** The Methodists organized a church in Helena in 1876 with W.H. Self as the first pastor and Dr. W.C. McCoy as presiding elder. Families instrumental in the organization were the Davidsons, Tuckers, Hayes, Lamberts, Echols, and Ruffins. In 1882, a new frame church was constructed on Second Avenue, between Second and Third Streets. It, too was destroyed by the 1933 tornado and then rebuilt on the same site. The Methodists remained there until 1981, when a new sanctuary was erected on County Road 58. (Randy Robinson.)

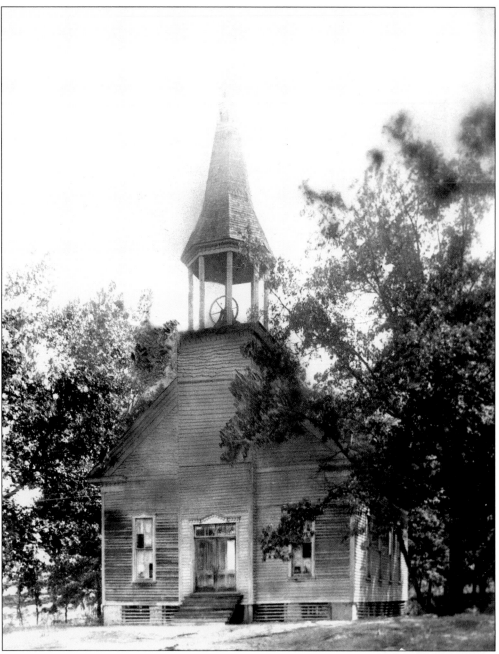

**HARMONY PRESBYTERIAN CHURCH.** The Presbyterians were the first to erect a house of worship in what would become the confines of Helena. About 1850, a congregation including the Lee, Griffin, Fields, Leonard, Davidson, and Roy families built a church where the town cemetery is located. Between 1886 and 1893, a new church was constructed where the current building stands, though that structure, pictured above, was destroyed in the 1933 tornado. (Randy Robinson.)

**JOHN FELIX MCLAUGHLIN, C. 1863.** Wounded at the battle of Gettysburg as a member of the Tenth Alabama Infantry Regiment, John Felix McLaughlin was in Montgomery convalescing when this photograph was taken. Surviving the war, he came to Helena to teach in the old schoolhouse near Harmony Church and the town graveyard. (Felicia McLaughlin.)

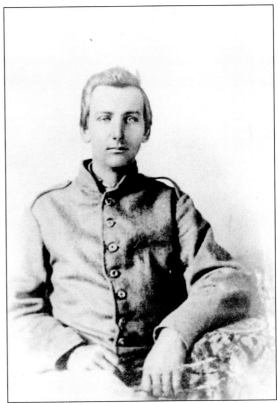

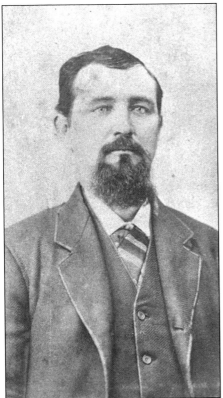

**OLLIE COST.** Before compulsory school attendance, Helena parents would solicit a teacher to come to the community and organize a school. A modest tuition supported the teacher. Ollie Cost (1846–1921) was one of the earliest to try his hand at making a living under such an arrangement. (Ken Penhale.)

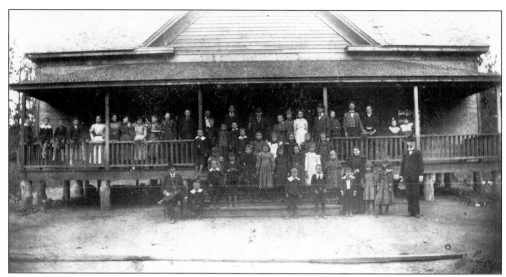

**HELENA SCHOOL.** The June 1913 headlines read, "Helena Public School Commencement a Success." Parents and other townspeople heaped praise on Miss Lucile Meddows, the principal, and her assistant, Miss Rainey, for the "thorough manner in which the children of the school have been trained, and for the excellent program arranged and rendered." (Marion Davidson Sides.)

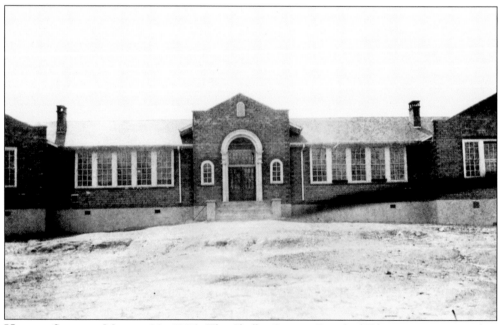

**HELENA SCHOOL, MARCH 29, 1925.** The Shelby County Board of Education announced in the fall of 1923 that a new junior high school would be built in Helena. Over $12,000 was set aside for the construction, and a stylish tile exterior finish was chosen for the building, which was completed in 1925. (Ken Penhale.)

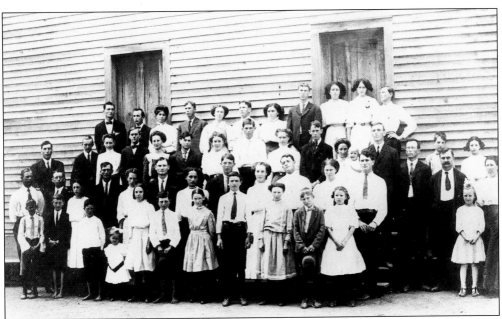

**HELENA HIGH SCHOOL, C. 1878.** The school was also known as the Helena Male and Female Collegiate Institute. The curriculum was impressive and included English, Greek, Latin, French, German, Music, Painting, Drawing, and Logical Bookkeeping. (Ken Penhale.)

**HELENA HIGH SCHOOL FLYER.** "Located in the thriving town of Helena," a local booster noted in 1878, "with pure air and good water, the school's location is all that could be desired. The Faculty is composed of educated, refined and accomplished instructors. This Institute merits success and will undoubtedly reap it." (Ken Penhale.)

# HELENA HIGH SCHOOL.

## MALE AND FEMALE.

Spring Term for 1878 opens January 14th. "The cheapest and the best" is our motto. "Labor omnia vincit," is our maxim. Subscribers pay only ONE DOLLAR per month. Any branch of the whole curriculum of Greek, English and Latin will be taught. "Order is Heaven's first law." Patronage solicited. Apply to Principal.

L. C. DICKEY,

Helena, Ala.

"A WISE SON MAKETH A GLAD FATHER."
*INDEPENDENT JOB PRINT.*

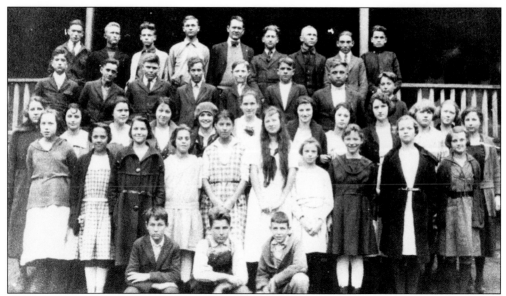

**HELENA SCHOOL, C. 1922.** The class of 1922 was one of the last to attend school in the 1890 building, which had been constructed after the 1878 Collegiate Institute burned. Dilapidated by 1922 and with its three rooms hopelessly overcrowded, the building was demolished to make room for a new school. (Jack Johnsey.)

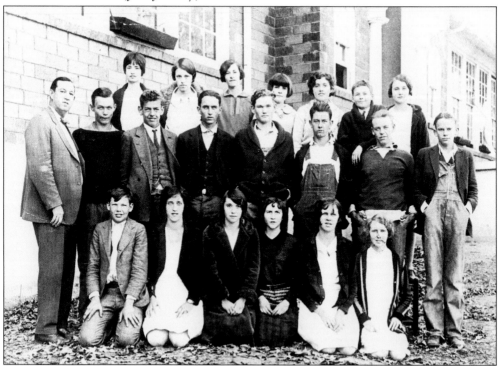

**HELENA SCHOOL, 1929.** The elementary school opened the middle of September with every room crowded. The high school, however, welcomed students back two weeks earlier to get in a full nine-month term, which was the school's first attempt to receive accreditation from the state. In 1929, Calera was the only accredited school in the county. (Ken Penhale.)

# Seven

# LEISURE

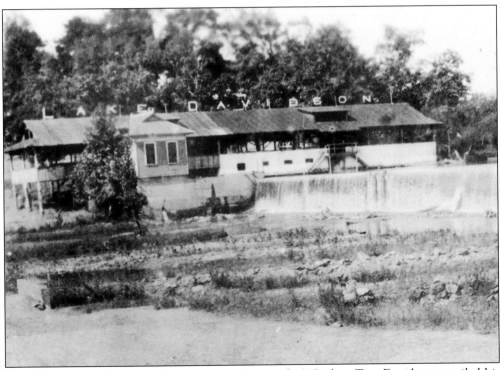

**LAKE DAVIDSON.** Helena took on a resort air around 1915 when Tom Davidson unveiled his plans to develop his property along Buck Creek. Fueled by the flush economic times preceding WW I, the skating rink that doubled as a dance hall was the center of "good times" for area residents. (Marion Davidson Sides.)

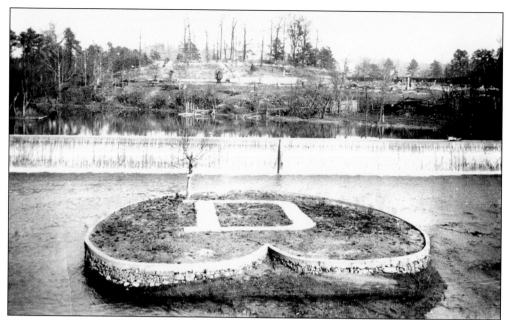

**DAVIDSON ISLAND.** Even the closing of many of the area's coal mines and the dismantling of the rolling mill that had been located directly behind the dam in this photograph did not quench C.T. "Tom" Davidson's flair and flamboyance. He constructed this island in the middle of Buck Creek sometime shortly after 1923. The island began washing away within a year. (Ken Penhale.)

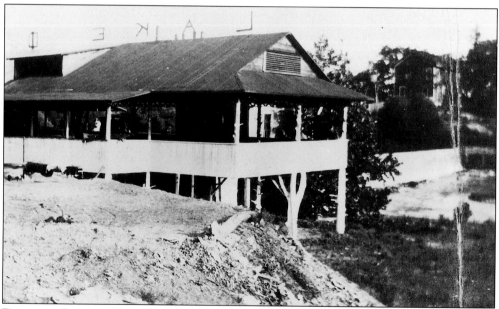

**DAVIDSON SKATING RINK.** Tom Davidson's sons, Jack, Bob, and Joe, joined him in his varied business ventures around town. With the addition of canvas awnings and drapes, the skating rink was transformed into a movie gallery by son Jack. (Peggy Lindsey Sprague.)

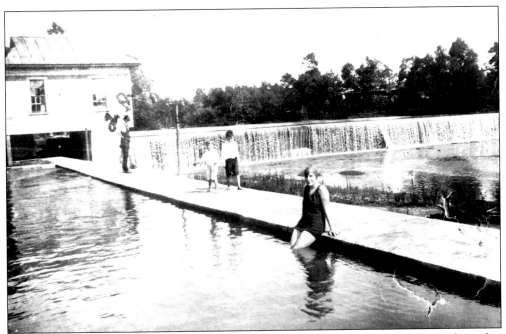

**DAVIDSON SWIMMING POOL.** A swimming pool was added to the Lake Davidson pavilion after WW I. The pool was lower than the main structure and featured dressing rooms below the rink, a dance hall, and a movie theatre. The immodesty of modern swimming attire was a common subject among town gossips. (Ken Penhale.)

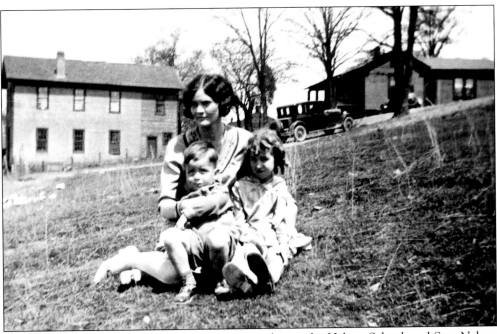

**EARLY SPRING OUTING, 1929.** Sue Braden, a teacher at the Helena School, and Sara Nelson and Bill Tucker enjoyed a pleasant afternoon in the spring of 1929. The Helena Masonic Lodge sits behind them. (Virginia Tucker.)

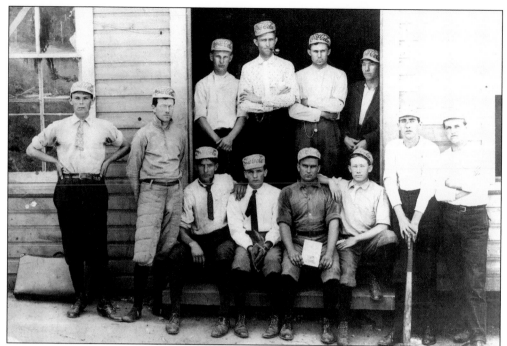

**HELENA BASEBALL TEAM.** The Helena boys met Wednesday evening, June 4, 1913, and organized a baseball team, claiming the best team ever organized at that place, with J.H. Hays as manager. They boasted the team was ready to accept challenges from any team in the United States and felt assured that a defeat of any challenger would result, one way or the other. (Alice Russell.)

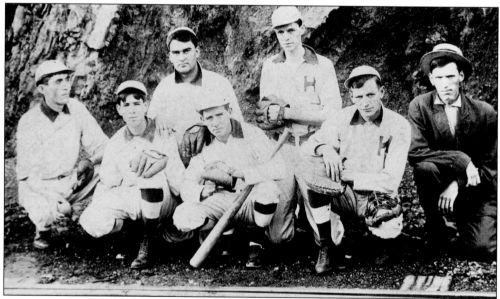

**HELENA BASEBALL TEAM.** The local baseball team was a source of great civic pride. Games provided an opportunity to visit other towns, renew friendships, and exchange information as varied as crops, working conditions in the mines, the latest political news, and good old-fashioned gossip. (Marion Davidson Sides.)

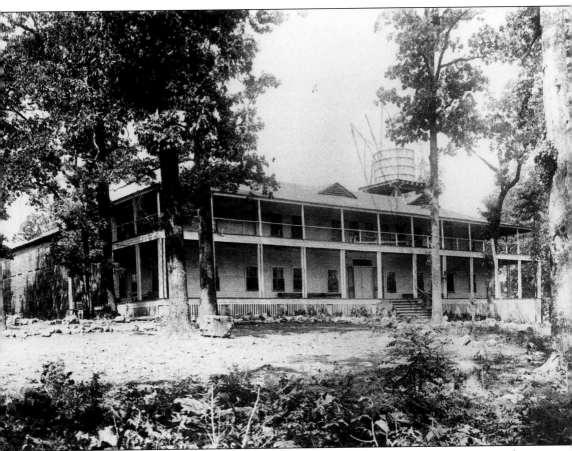

**PELHAM HEIGHTS HOTEL.** With a grand vision of annual religious encampments atop the mountain between Pelham and Helena, the Baptists of Alabama constructed a 60-room hotel, large dining hall, and auditorium together with 50 tents, a swimming pool, and tennis courts in the summer of 1912. A resort of national reputation was planned, with privately owned cottages nearby. The evangelical fervor of the first season did not last, however, and the complex became a local resort with what was touted as a fine view of Pelham, Helena, and Keystone. Sometime in the 1920s, the hotel and adjoining structures were dismantled and moved to Cook Springs in St. Clair County. (Randy Robinson.)

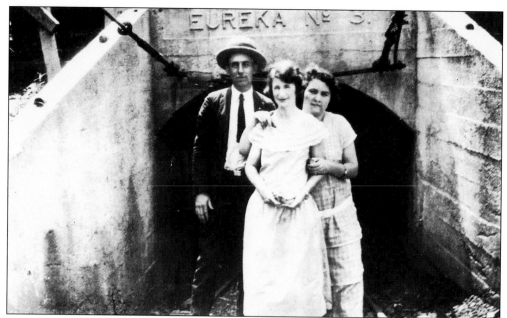

**SIGHTSEEING AT THE COAL MINES, C. 1923.** The abandoned Eureka Number 3 Mine provided Garland Bishop, Ina Mae Floyd, and Marie Bald with an interesting spot for an afternoon outing and photo opportunity. (Ken Penhale.)

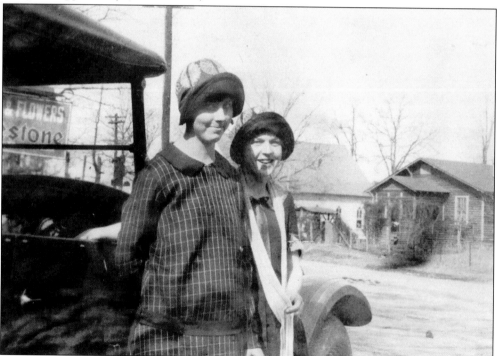

**AT THE FILLING STATION.** Most townspeople, at least those with automobiles, visited Floyd and Flowers Garage at one time or another. Mary Lou Hinds and Catherine Chapman, dressed in the flapper style of the "Roaring 20s," posed for this photograph in 1923. A corner of the Helena Baptist Church can be seen in the background. (Ken Penhale.)

**CYCLING, C. 1917.** While the bicycle could be a serious mode of transportation, in Jack Davidson's case it provided a pleasurable way of sporting about town. (Margaret Lindsey.)

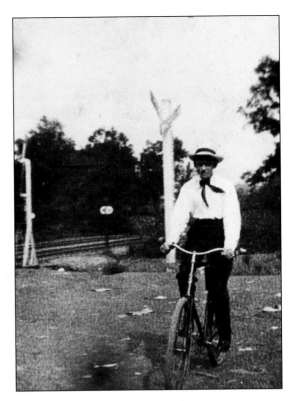

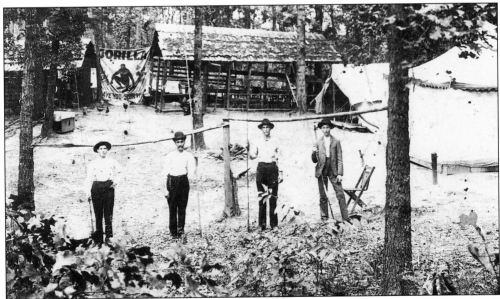

**PINEY WOODS TANK FISHING CAMP.** Frank Hinds, Doc Kennedy, Allen Disney, and Will Hinds descended upon the Cahaba River in May 1907 to join in the annual frenzy of snaring redhorse. A member of the sucker family, the redhorse spawned in great numbers in shallow gravelly spots in the river. The fish could not be caught on a hook, so a wire was attached to the end of a long pole and tied in a loop resembling a lasso. A wily sportsman would then have to slip the loop over the fish and yank to catch the prize or a meal. (Ken Penhale.)

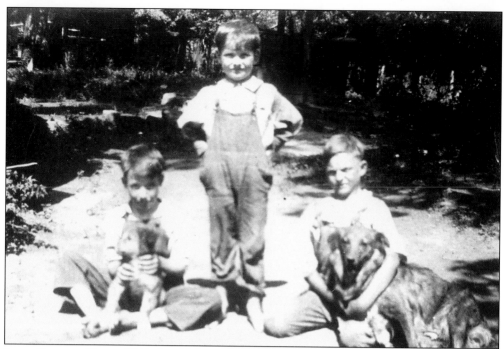

**LAZY SUMMER DAYS, 1916.** Could there be a better way to spend a day than playing around in the backyard, barefooted, with your dog? Pictured from left to right, Bill Bramblett, Millard McGlawn, and Howard Bramblett were seriously contented in the summer of 1916. (Lois McGlawn.)

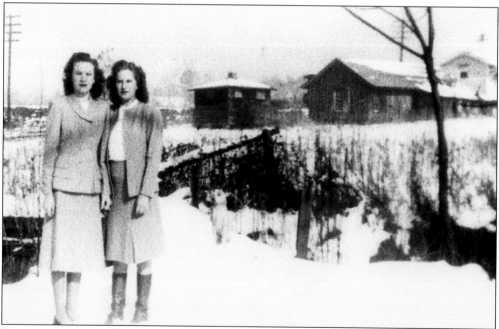

**FASCINATION WITH SNOW, 1948.** Time stops when it snows in Alabama. Sisters Lois England McGlawn and Ozella England Wilson commemorate the occasion with a photograph. The old town jail and freight house is in the background. (Lois McGlawn.)